IMAGES
of America

AROUND
BENSON

IMAGES
of America

AROUND
BENSON

E. Kathy Suagee and the
San Pedro Valley Arts and Historical Society

Arizona Historical Foundation

ARCADIA
PUBLISHING

Published by Arcadia Publishing
Charleston SC, Chicago IL, Portsmouth NH, San Francisco CA

Printed in the United States of America

Library of Congress Catalog Card Number: 2008928328

For all general information contact Arcadia Publishing at:
Telephone 843-853-2070
Fax 843-853-0044
E-mail sales@arcadiapublishing.com
For customer service and orders:
Toll-Free 1-888-313-2665

Visit us on the Internet at www.arcadiapublishing.com

*This book is dedicated to the hardworking volunteers at San Pedro Valley
Arts and Historical Museum. Without their archives, this book would
not be possible. Some of the author proceeds from sales of this book will
help the museum achieve needed improvements.*

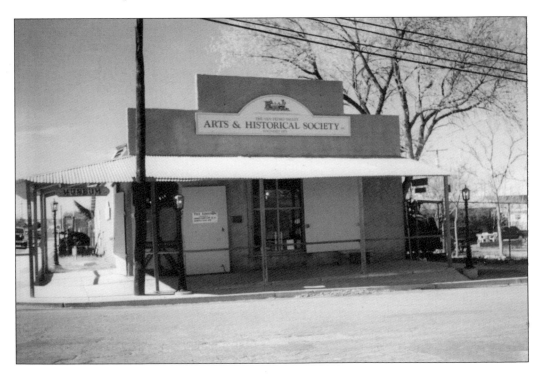

CONTENTS

ACKNOWLEDGMENTS

I was pleased to be asked by Jack August of the Arizona Historical Foundation to create this book about Benson as part of the Arizona Centennial Project. As manager for the Singing Wind Bookshop north of Benson, I am frequently asked if there are any materials about this part of the San Pedro Valley. Not many resources exist. I hope this book inspires a gathering of historical materials and stories that will flesh out the history of this part of the Southwest.

Historian C. L. Sonnichsen said, "We all know that history is what everybody agrees to believe about any portion of the human past." Urban legends abound on the frontier because stories transmitted orally, across time and between cultures, tend to get muddled at times. In finding Benson's past, I have attempted to bridge both time and culture to replay the past, knowing full well that I am a novice in this enterprise. I gratefully and humbly thank all those who have helped along the way.

Thanks, especially, to Stan Benjamin for organizing the materials at the museum into files and displays and for all his help and advice. Thanks also to individuals and families who have shared their pictures, their stories, and their knowledge, especially the Comaduran family, Dora Ohnesorgen, W. Lane Rogers, Bob Nilson, Jim Kelly, and Winifred Bundy. A special thank-you is due Jared Jackson, my editor, for his patience, encouragement, and lessons in technology.

Unless otherwise stated, photographs contained herein were provided courtesy of the San Pedro Valley Arts and Historical Museum in Benson, Arizona.

INTRODUCTION

When it came to westward expansion in the United States, Arizona was a "last best place." The wide deserts, although not Saharan in nature, presented exceptional challenges to early explorers and travelers. This land was home to nomadic bands of Apache Indians when the first wave of Europeans, the Spanish explorers, entered from the south searching for wealth and candidates for Christianity in the 1500s. The strength of the Apaches restricted immigration for hundreds of years.

Cochise County, named after the Apache who was the Chiricahua band's leader during much of the 19th century, includes the San Pedro River, which runs north out of Mexico. Sabaipuri Indians lived near the San Pedro River, using the free-flowing river waters for irrigation, when Spanish missionaries led the migration in 1692. Fr. Eusebio Kino brought in cattle, corn, wheat, barley, figs, and grapes and encouraged the Sabaipuri to form *rancherias* with Spanish settlers to grow these things. But the Apaches did not tolerate Spanish settlement of the San Pedro Valley, and soon the rancherias were abandoned, and Spanish and Native American farmers gathered closer to San Xavier del Bac in the Santa Cruz River Valley.

The attraction of a southern route to California, however, could not be denied. Although the danger was great, by the 1850s, an American presence was firmly established on the San Pedro River near Tres Alamos, previously a Sobaipuri Indian site and, before that, a Salado culture camp. The Butterfield Overland Stage provided swift travel through the territory for a brief three-year period from 1857 to 1860, crossing the San Pedro River about one mile north of present-day Benson.

Present-day New Mexico and Arizona were made a U.S. territory in 1850. Arizona was made a separate territory in 1863. The Gadsden Purchase of 1854 added the southernmost part of both states to the territories. With territory status, the Homestead Act allowed settlement for Americans, but some delay occurred because of the Civil War. Apaches maintained their ownership of the region and acted accordingly, but military support of homesteads had to wait. After the Civil War, homesteaders and fortune seekers began migrating to Arizona in increasing numbers.

Part of the attraction of easterners to the West was the chance to exploit its resources. Explorations for gold, silver, and other minerals were successful, and the mining towns of Tombstone, Bisbee, and Clifton, as well as smaller mining districts, soon produced a demand for railroad services. The Southern Pacific waged a battle in Congress against other contenders for easement rights across southern Arizona, and Benson became important as the meeting-point of three railroad lines. The resultant growth of the town promised much, and Benson was dubbed "the Hub City," but ultimately, as mining waned, Tucson won the honor of "Railroad Town."

An ever-present ranching and agriculture commerce tided Benson over during years of hardship between transportation boom and bust. The automobile provided the final wave of transportation boom. As paved highways developed along established transportation corridors, Benson again profited. New businesses included motor courts, restaurants, filling stations, and auto repair shops. Benson also became a popular vacation spot for winter visitors. From the 1920s until the freeway bypassed Benson in 1974, Benson prospered modestly, surviving slowdowns, including

the Depression of the 1930s, as well as the booms of the First and Second World Wars. Stalwart families kept the town alive, staying on when others took the roads out.

Created and defined by transportation, Benson's historical journals abound with pictures of Fourth Street, the main thoroughfare, yet behind this main street, the real story of Benson has played out. Doctors, teachers, cowboys, laborers—all the people who were here at the start and whose families are here yet—comprise the real history of Benson. Without their resilience and dedication to creating a community, Benson would not have achieved its first 100 years. There will always be those who pass through and those who stay only to make a fast buck, but the ones who stay embody Benson's heart and its history.

Benson survives today much as it always has, welcoming travelers passing through while inviting them to take a longer look, to enjoy the clear skies and drink the fresh artesian water. The water is, in the final analysis, both Benson's chief asset and its possible undoing, as the West becomes a playground for retirees from throughout the country and land developers—like the exploiters of mining in days past—look for an easy way to make a dollar.

One

EARLY TRAILS AND TRANSPORTATION

All rivers must be crossed. The San Pedro River of Arizona and the mountain ranges between which it flows combine to point travelers to a spot now known as Benson. The story of Benson's first 100 years abounds with tales of travel. As people sought routes from east to west or south to north, all the topography led to this spot.

The Spanish pre-dated American travelers by several hundred years, and Native Americans long before that, but settlement was kept to a minimum by Apache bands who claimed the land. Early American travelers through this area included the Mormon Battalion in December 1846, who came down the San Pedro River (heading north) looking for a route to the coast. Twelve years later, the Butterfield Stage established a trail from St. Louis to San Francisco, a journey of 2,535 miles, which the stage traversed in an amazing 24 days. The most dreaded part of the journey was from Mesilla, New Mexico Territory, to Tucson—Apache country—traversing the San Pedro River about one mile north of present-day Benson.

According to early accounts, the San Pedro River in the early 1880s was 8–10 feet deep. In places, one could step across it. After the earthquake of 1887, multiple artesian springs surfaced in St. David and Benson, while the river dropped and widened noticeably. Both water and hot rocks spewed from the ground, the rocks setting fire to the abundant grasslands. The subsequent runoff from storms further eroded the banks, and it was said the river "went underground."

Southern Pacific Railroad reached the San Pedro River in 1880, and Benson was established. Credit for the town's name varies, but the most popular idea is that Southern Pacific president Charles Crocker named the spot Benson in honor of his friend Hon. William B. Benson. The opinion of many in Tombstone was that the town would not amount to much. Despite their skepticism that water would not be found, water was discovered, sweet artesian water, which 100 years later would be coveted by a new age of developers. By 1895, Benson had become a thriving intersection of three railroads and was dubbed "The Hub City."

Cochise County, Arizona, encompasses over 6,000 square miles, sharing borders with New Mexico in the east and Mexico in the south. For the brief period of 1872–1874, much of what is now Cochise County was designated as the Chiricahua Apache Reservation. Benson was founded on the banks of the San Pedro River in the northwestern quadrant of the county, 45 miles from Tucson.

The Mormon Battalion explored a favorable route west for the U.S. government, while scouting out future destinations for themselves. Their only skirmish in over 2,000 miles, from Council Bluffs to San Diego, was with a herd of wild Spanish bulls. They turned west near present-day Benson on December 14, 1846. St. David, south of Benson, established 1877, is the only settlement later made along their route. (Author's collection.)

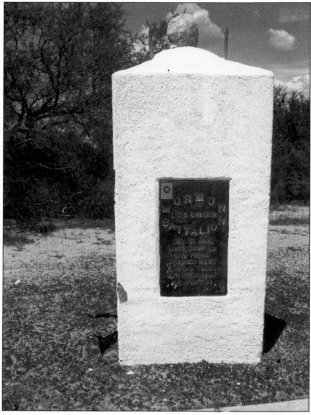

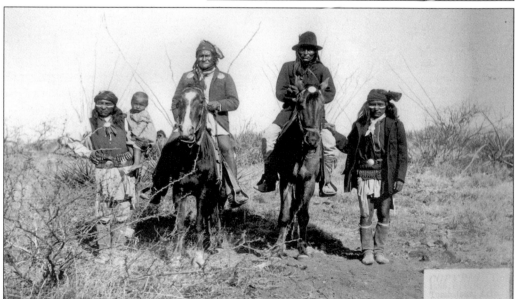

Apache Indians dominated southeastern Arizona and southwestern New Mexico when Spanish settlers arrived in 1539 until Geronimo's surrender in 1886. Even then, a few renegade individuals and bands of Apaches remained in the mountains of northern Mexico until the 1920s and even into the 1930s. (Arizona State Library, History and Archives Division, Phoenix, 97-2651.)

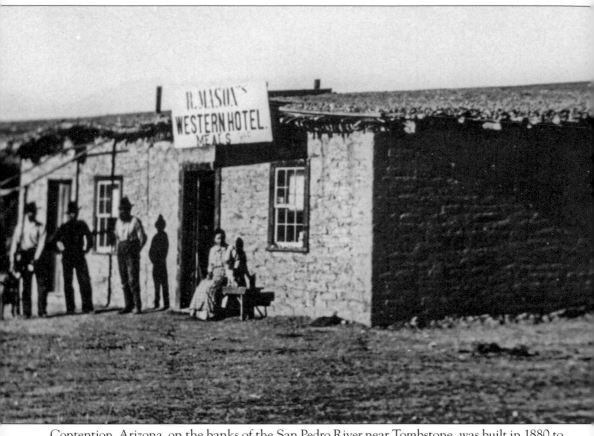

Contention, Arizona, on the banks of the San Pedro River near Tombstone, was built in 1880 to serve as a mill town for Tombstone. Its life span was fewer than 10 years, as the mines in Tombstone flooded and mining there came to a halt, thus ending the need for this smelter town.

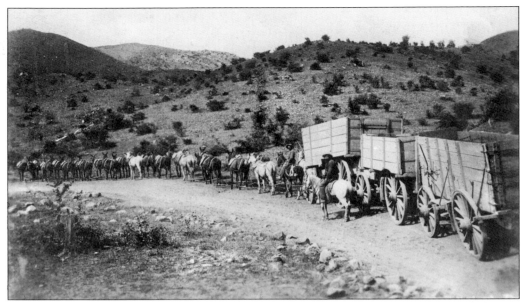

Arizona mountains proved rich in silver and copper ores. Moving the ore required hardy men, mules, and wagons. The territory desperately needed rail service to make production more lucrative for all. Wagon trains from Clifton, which previously hauled copper ore all the way to Colorado, were diverted to Benson after 1880, a significantly shorter distance.

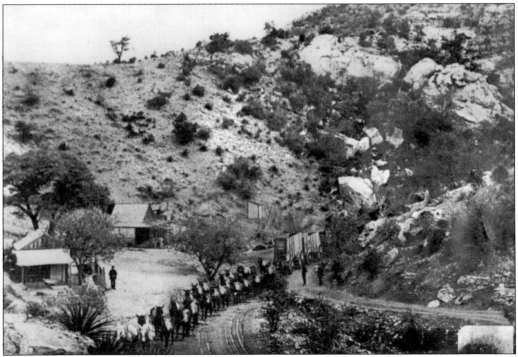

A mule train readies for another long trip out of the Mule Mountains and Bisbee. The mules apparently did double duty, pulling the wagons while packing bags on their backs.

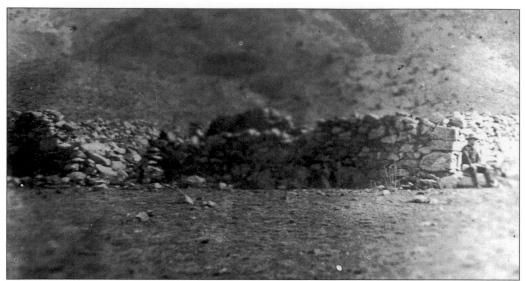

Dragoon Springs provided a guarded resting point along the Butterfield Overland Stage Trail. Even in its establishment as a stage station, this place inspired violence. While building it, Mexican laborers attacked their American companions, killing three. A man named St. John survived four days with a partially severed arm, living to tell the story. (Arizona State Library, History and Archives Division, Phoenix, 97-1212.)

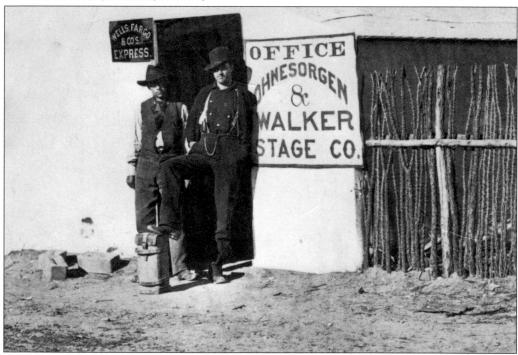

William Ohnesorgen (right) and partner Henry C. Walker started a six-horse stage to Tucson and Tombstone from their station on the San Pedro River. In 1879, they completed a toll bridge over the river, which at that time was only 25 feet across. After a brief boom as machinery bound for Contention, Charleston, and Fairbank crossed the bridge, Ohnesorgen sold out in 1880. A flood washed away the stage station in 1883.

Southern Pacific Railroad Company (SP) moved quickly across Arizona to establish the southern transcontinental line. They had submitted their map of a proposed railroad through southern Arizona to the Department of the Interior on November 12, 1874, securing an edge on Texas and Pacific Railway Company, which had previously reserved the easement, but had not produced a railroad. The town of Benson was established along the SP line in 1880.

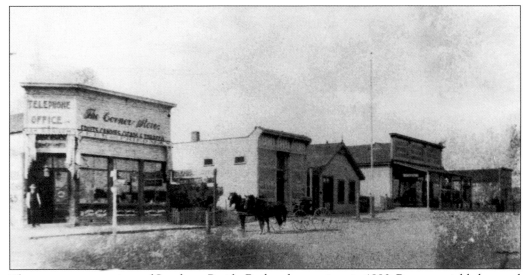

The temporary terminus of Southern Pacific Railroad operations in 1880, Benson quickly boomed to a bustling center of transportation and business enterprises. The Corner Store at Fourth and Huachuca Street advertised both produce and communication as commodities. Citizens Bank is next down the street, then Leonard Redfield's house, and the Mansion Café and Hotel.

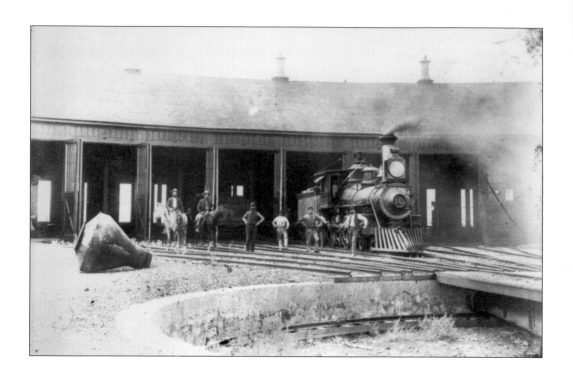

Extra engines were necessary in Benson, at an altitude of 3,565 feet, to help trains up the steep valley slopes. The second steepest valley in the United States, San Pedro Valley, terminates at Dragoon Summit, the highest point on this rail line west of the Rio Grande (4,613 feet), which includes a climb of 1,048 feet within 15 miles. Both Southern Pacific and New Mexico and Arizona Railroads placed roundhouses as well as depots in Benson. The straight stack on the engine replaced the diamond stack on the ground. (Both images, Bob Nilson.)

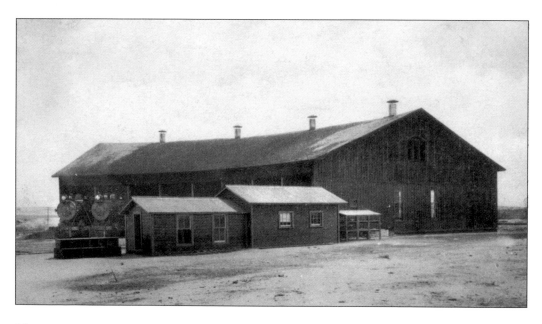

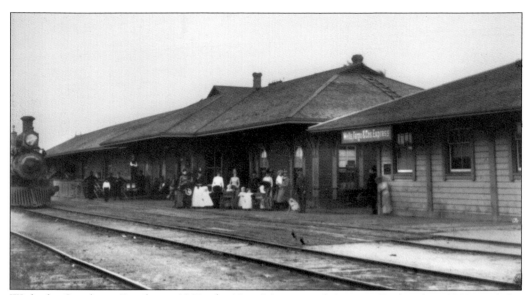

With the Southern Pacific in 1880, the New Mexico and Arizona Railroad in 1882, and the Arizona and South Eastern line in 1894, Benson was indeed a hub of commerce and culture. The Arizona and South Eastern ran from Guaymas, Mexico, to its terminus at the Southern Pacific line, sharing the Southern Pacific station (above) with tracks for Southern Pacific on the north side. The separate building was Wells Fargo.

The S&W Smelter operated intermittently from 1882 until 1909, when it was dismantled and shipped to Mexico. Benson had the capacity to produce 200 tons of ore per day. The process of taking ore from the rock, leaving slag while producing bullion, resulted in a mountain of slag, which was later purchased, hauled to El Paso, and further smelted. (Bob Nilson.)

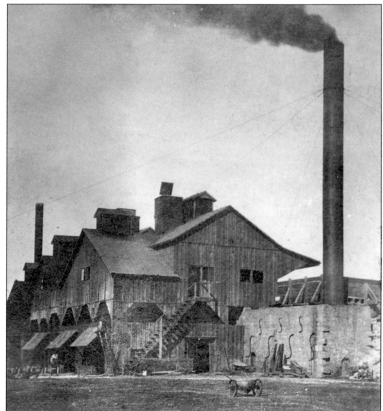

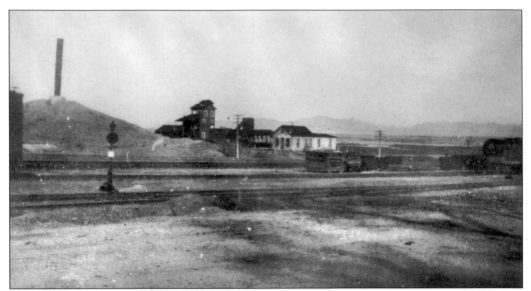

Southern Pacific Railroad, New Mexico and Arizona Railroad, and Arizona and South Eastern Railroad converged near the S&W Smelter in 1910. A spur line ran from the smelter, located on the southeast side of Tank Hill, to the Southern Pacific tracks.

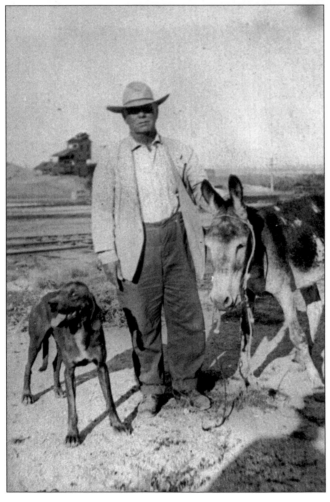

An unidentified man stands with his hunting dog and his burro south and east of the Benson smelter near the Southern Pacific roundhouse.

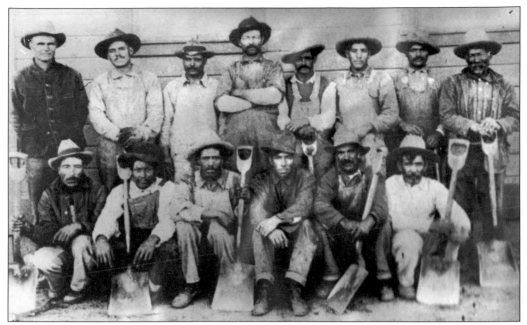

A Southern Pacific work gang of the 1920s included many whose families still reside in Benson. They are, from left to right, (first row) ? Tenario, unidentified, Silvestre Gardillo, and three unidentified; (second row) unidentified, Antonio Salazar, Aurelio Calderon, Ambrose Hernandez, Juan Bernal, Patrillo Tenario, unidentified, and Gregario Salazar.

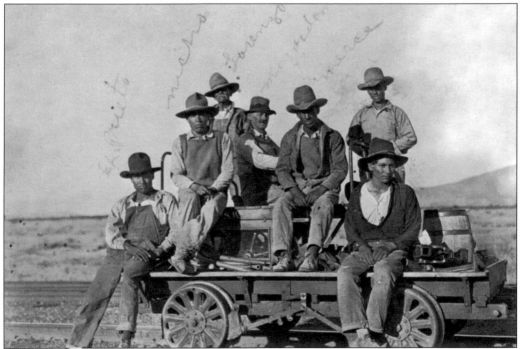

Men on the hand car are identified as El Prieto, Necho, Lorenzo, ? Jordon, Merce, unidentified, and Steve Gonzales. This vehicle, powered by hand, was used to move crews up and down the line to make repairs.

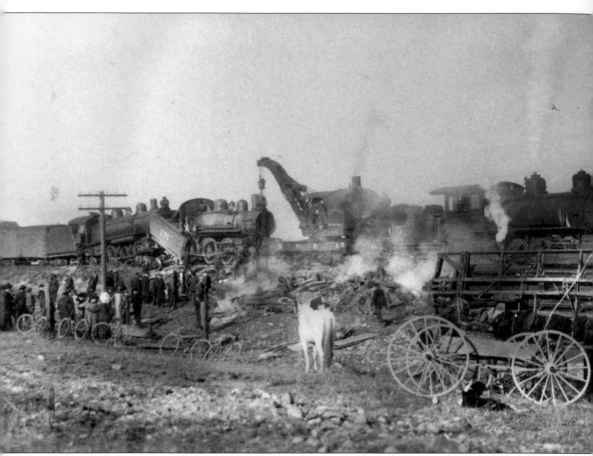

Possibly one of the first train wrecks around Benson, this one was close enough that local residents could ride their bicycles to go watch the cleanup. The crane was a necessary piece of machinery to right these coal-powered engines.

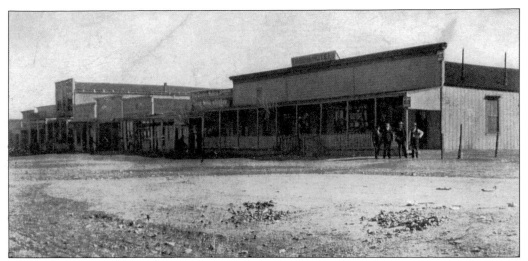

An early street scene after the fire of November 1905, looking east from Huachuca Street, shows many buildings rebuilt between the Virginia and Mansion Hotels. The fire began behind Redfield's General Merchandise store, spreading to destroy the Turf Saloon, Ohnesorgen's Elite Saloon, two Chinese restaurants, and damaging the Mansion Hotel. The Wild Cat Saloon, owned by Fred Clark, also was destroyed. (Stan Benjamin.)

Ranching has always occupied an important place in Benson history. A holding pen and loading ramp accommodated ranchers' cattle when the time came to send them to market.

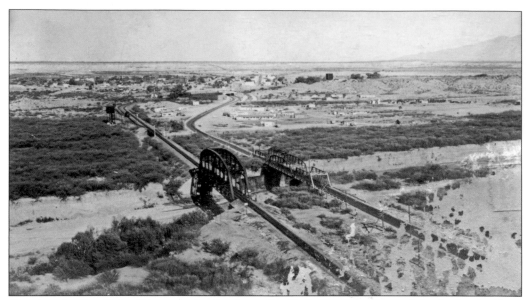

Crossing the San Pedro River are the Southern Pacific Railroad Bridge and the bridge for State Route 86, the "Sunset Trail." Route 86 was hewn through Texas Canyon in 1933 and paved in 1941. The river is considerably wider than the 25 feet Ohnesorgen and Walker had to deal with 60 years earlier.

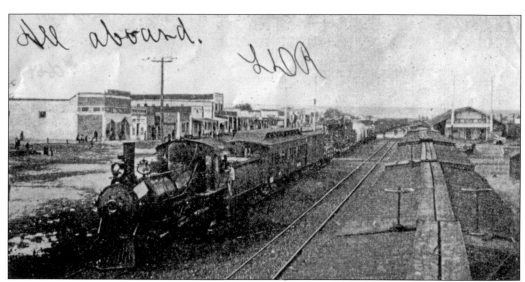

Around 1900, at far right, is the Benson Depot of Southern Pacific. The tracks are those of Arizona and South Eastern Railroad. The locomotive is heading east now, but within a block, it will turn south for travel to points as far as Guaymas, Mexico. On the other side of the depot, Southern Pacific tracks carried passengers and freight to points farther west and east.

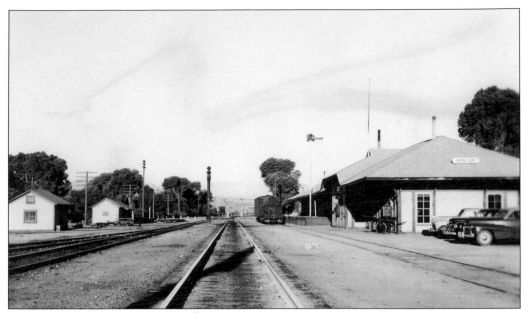

By 1943, only the Southern Pacific tracks remain. This view is looking east, toward the river. The land formerly occupied by the Arizona and South Eastern, cleared of tracks, was leased, mostly to gasoline filling stations that serviced autos in the new transportation era. (Bob Nilson.)

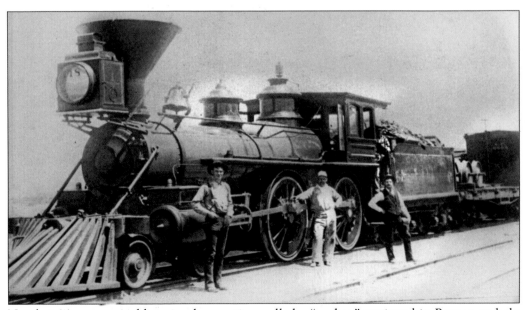

Number 18 was a wood-burning locomotive, called a "pusher," stationed in Benson to help trains climb the long grades out of the valley. Notice the diamond stack, later replaced by a straight stack.

Dragoon Summit (4,613 feet), at the base of the Dragoon Mountains, is the highest point west of the Rio Grande on this rail line. Nearby Dragoon Springs was established in 1857 as a stop for the Butterfield Stage. On a rare day of snow and fog, railcars await their trip to Benson. The depot,

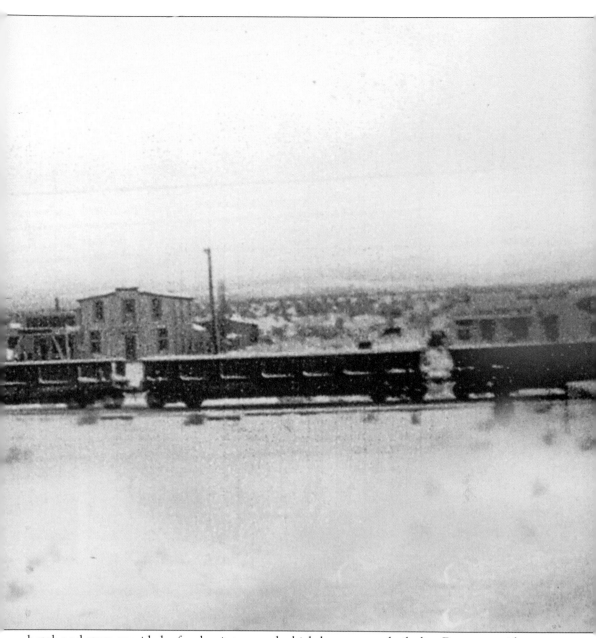

hotel, and store provided a focal point around which houses were built, but Dragoon residents have never incorporated or had aspirations to be anything other than rural. If one peers into the distance, snow-filled mountain cleavages can be seen.

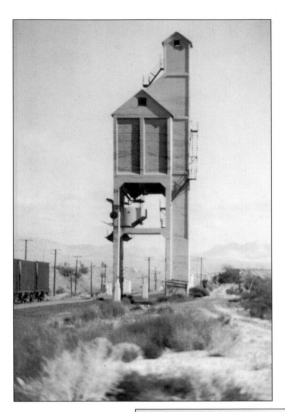

In the plains west of Benson in 1973, at a stop named Mescal, a coal tower still stood that serviced engines about to cross the valley or those that just had.

Either the engineer of the train in this c. 1973 photograph did not take into consideration the speed he could gain coming into Benson, or upheavals of the earth caused the tracks to misalign. To the east of this site is a curve where the railroad crosses State Route 86. The water tower on Tank Hill marks the former site of Benson's smelter.

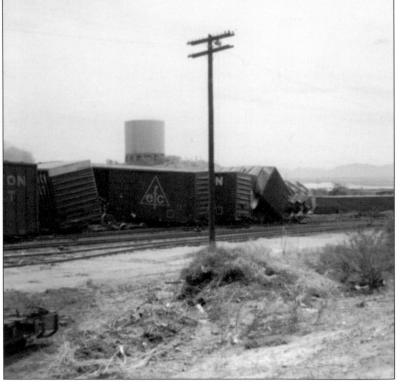

Two

EARLY FAMILIES

The cast of characters coming to Benson mirrors other southwestern communities. There were doctors and lawyers, laborers and storekeepers, teachers and cowboys, Anglos, Mexicans, and Chinese. The names of early settlers still adorn the rolls of local schools: Ohnesorgen and Pacheco, Castillo and Judd, Comaduran and Sabin, Bernal and Ellsworth, to name a few. These are the people who established the institutions—the churches and schools, the businesses and government—that give permanency to a town. The earthquake of 1887 damaged buildings; tragic loss of life occurred in the flood of 1896; and fires of 1882, 1883, 1886, 1905, and 1921 destroyed much of the business district, but Benson pioneers always rebuilt. Even when the railroad moved its operations to Tucson in 1911, pioneer families could not abandon their homes near the San Pedro River, in the beautiful valley of clean air and artesian water.

In the portraits of early pioneers, we see pride, dignity, love, and optimism. We see how some strove to maintain a sense of "high society" on this western frontier, and we see the homes that sheltered them from the heat and the cold. Yes, cold! About 1,000 feet higher than Tucson, Benson's Chihuahuan desert temperatures have lower extremes than that Sonoran desert city.

John Henry, first station master in Benson, came from Indiana. He apparently served in the military, as displayed by the garb he wears here. John Henry married a local woman, Gorgenia Morena, whose family owned much of the land on the eastern side of Benson. They had a daughter, Angelita Henry, born around 1874. (Both images, Comaduran collection.)

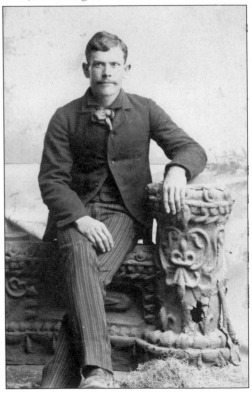

This tintype of an early Arizona settler is possibly a Comaduran, whose ancestor, Jose Antonio Comaduran, was Tucson's *comandante* during the Mexican period. (Comaduran collection.)

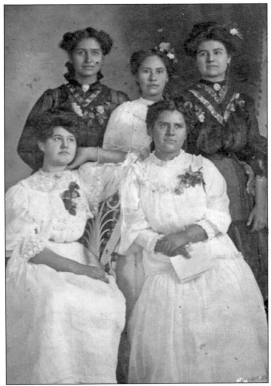

Five good friends pose for the camera in 1914. They are, from left to right, (first row) Eliza Ohnesorgen Pacheco and Rita Quihuiz Bernal; (second row) Aurora Bauerlin Bernal, Mercedes Figueroa Hall, and Concepcion Ohnesorgen Soto.

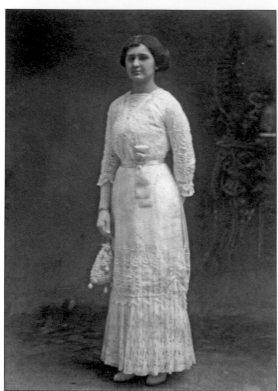

Dora Ohnesorgen identifies this lovely lady as Beatriz Ohnesorgen Bernal, sister of Eliza Ohnesorgen Pacheco. Written on the back is an endearing message: "A remembrance to my beloved sister in proof of my love and friendship from her sister. May 25, 1914." Elegance in 1914 was not something reserved for Easterners. (Comaduran collection.)

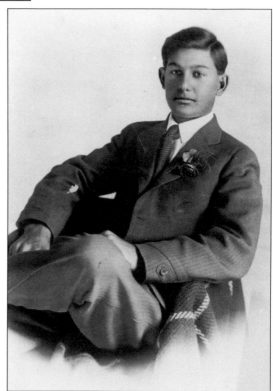

Edward Ohnesorgen, father of Dora, was a dapper young lad at the dawn of the 20th century. He later helped build the first Catholic church. (Comaduran collection.)

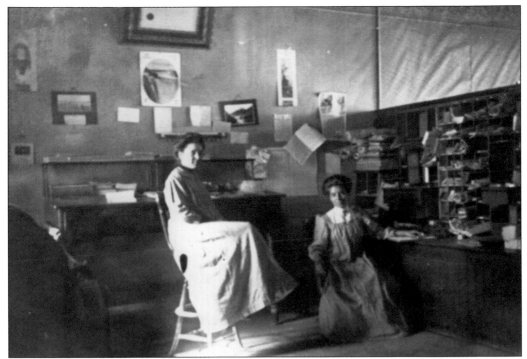

Christine Klinkman (left) and Laura Martinez (right) pause in their daily postal chores in early 1900s. Their combined English and Spanish language skills no doubt were a bonus to the multicultural town.

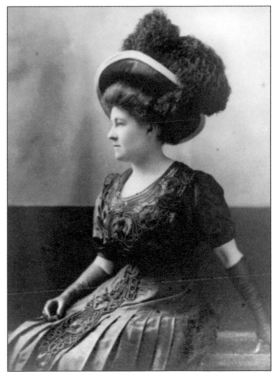

An elegant Pearl Hall Allan poses in her finery. Allan's husband, M. H. Allan, owned the corner drugstore at Fourth and Huachuca Streets in the early 1900s. When he died, she employed William Hamilton as druggist and later sold to him. His son Dick Hamilton took over the business, retiring and closing the drugstore, then at Fourth and San Pedro Streets, in 1998.

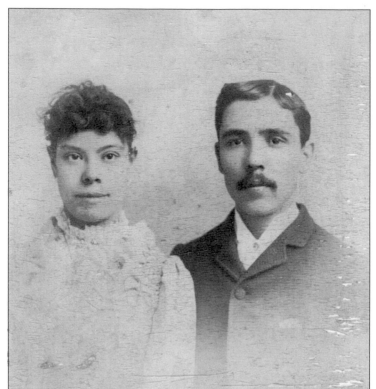

Stationmaster John Henry's daughter, Angelita, married Antonio Comaduran, probably sometime in the 1890s. Their daughter was Josephine, whose great-grandchildren still live in Benson. (Comaduran collection.)

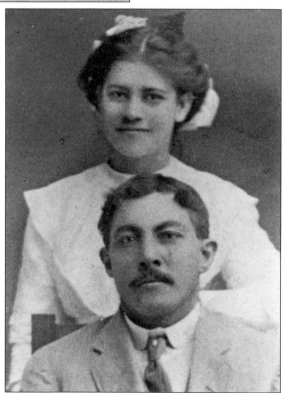

Ignacio M. Montijo and Juaquina Cota Montijo married around 1876. Their son was Nacho Montijo who was Albert Comaduran's maternal grandfather. (Comaduran collection.)

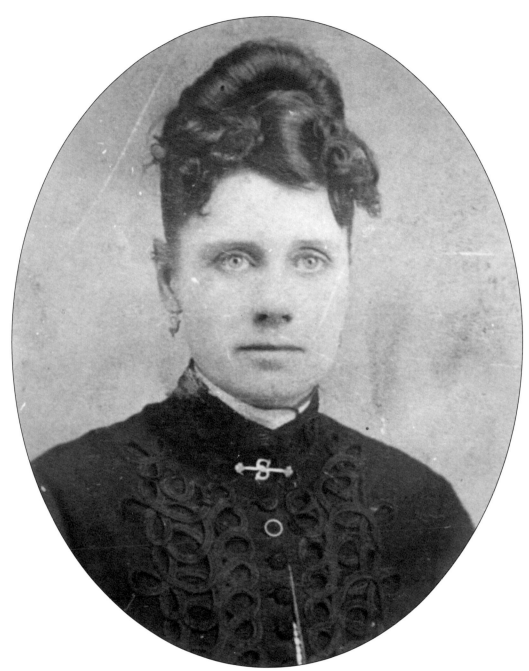

Sallie Bomar Eaker Watkins, wife of Dr. Henry Watkins, illustrates the impermanency of last names for many frontier ladies. Death of a spouse and remarriage were common to both men and women. Arriving in 1897, Sallie quickly earned respect for her charity and good Southern manners. She died in 1908. Her husband, Dr. Watkins, had preceded her in death.

The Clark house was an architectural experiment in insulation. The double roof was meant to form a barrier to heat, making the house cooler, and probably worked as insulation against the cold as well. Although storm damaged, this house still stands in 2008.

Here is a closer look at the Clark house, with Carrie Clark (left) and her friend Edith Watkins on the porch. The brick building seen through trees on the right was demolished in 2003.

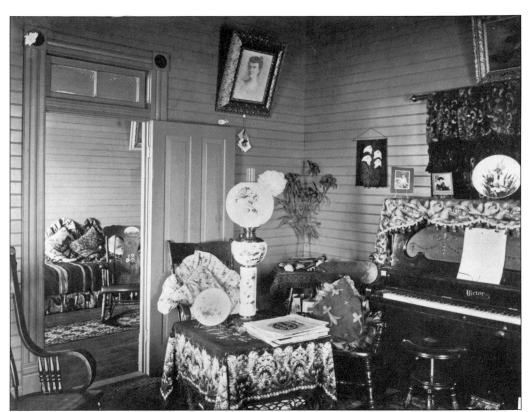

The Sam Friedman home evokes a classic Victorian atmosphere, with a drape on the piano and pillows galore. This is a rare look at life inside a Benson home in the 1890s.

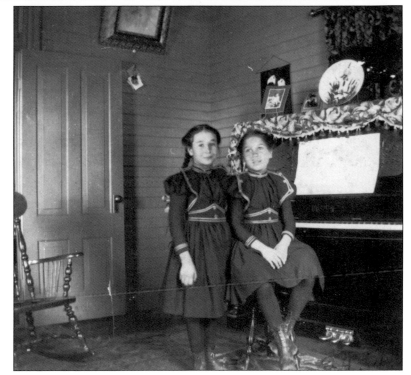

Sam Friedman's daughters, Lillian (left) and Hilda (right), pose next to their piano around 1900. The luxury of having a piano gave these girls an opportunity many probably envied.

Joseph A. Robinson founded nearby Pomerene, across the river from Benson and downstream about two miles. Pomerene became an agricultural center, with many Mormon families emigrating there from Mexico during the Mexican Revolution in 1912. They had sought haven in Mexico when Congress passed the Edmunds Bill in 1882, cracking down on polygamy. With trains from Mexico terminating in Benson, Pomerene was a natural destination for Mormon families fleeing Mexico. The first post office was named Robinson and was later changed to Pomerene, which was the last name of an Ohio politician.

The Walker home, at the corner of Fifth and Huachuca Streets, was only a block from Henry Walker's pharmacy between Huachuca and San Pedro Streets. A post office building was constructed on this lot in the 1960s.

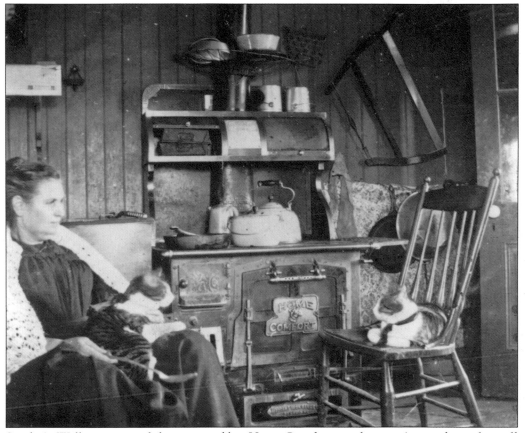

Sarah A. Walker poses with her cats and her Home Comfort wood stove. A saw adorns the wall above the stove, ready for service.

Armida Romero (left), unidentified, and Luci Calderon (right) pose in their finery for the camera. They may have been on their way to a wedding. (Comaduran collection.)

Hi Wo (1857–1931) came to Benson in 1896 and started the Hi Wo Grocery at the corner of Fourth and Gila Streets. He sold dry goods both retail and wholesale. Ranchers drove wagons to town and bought supplies for six months, often bartering hay and grain. (Comaduran collection.)

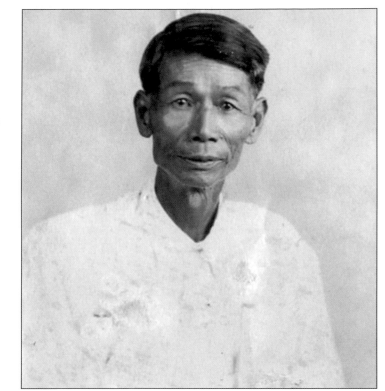

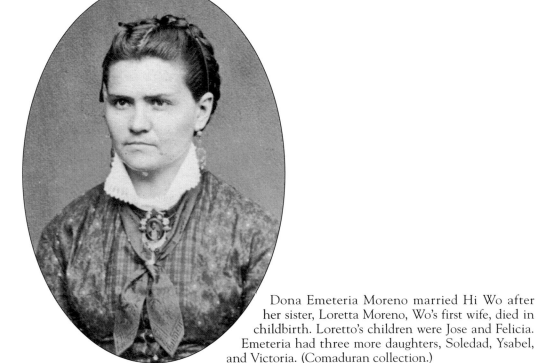

Dona Emeteria Moreno married Hi Wo after her sister, Loretta Moreno, Wo's first wife, died in childbirth. Loretto's children were Jose and Felicia. Emeteria had three more daughters, Soledad, Ysabel, and Victoria. (Comaduran collection.)

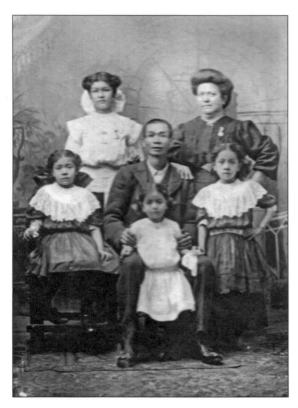

Hi Wo poses with his wife Emeteria (back right) and daughters, from left to right: Victoria (1903–1990), Felicia (1894–1977), Ysabel (1906–1991, in front of Wo), and Soledad (1902–1994). Missing from this family photograph is the only son, Jose (Joe). (Comaduran collection.)

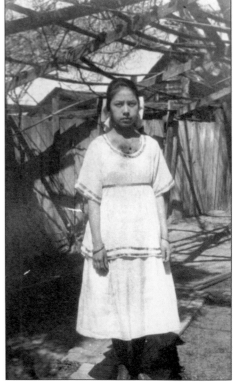

Victoria wears a special dress, perhaps on her way to a church ceremony. The Wo sisters remained devout Catholics all their lives. (Comaduran collection.)

Ysabel (left) and Victoria Wo display their amazing locks of hair while tending a baby dressed in Chinese garb. The baby may be their nephew Albert Comaduran. (Comaduran collection.)

From left to right, Ysabel and Felicia Wo (first row) and Victoria Wo (second row, left) pose with their friend Leontine Pacheco (second row, right). The tower on the hill provided water to the town, while the bigger one serviced the trains. Men in the background seem to be making an important decision. This is east of Gila Street before the highways that now meet there were completed. (Comaduran collection.)

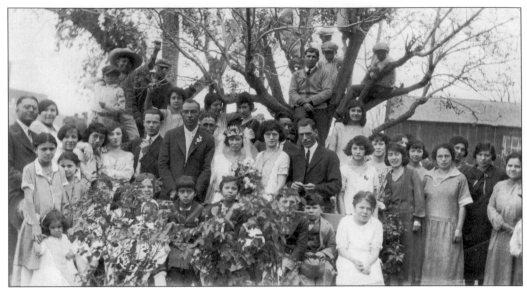

Everyone wanted to be in the wedding picture when Felicia ("Lecha") Wo married Dario Castillo. Next to the bride is Soledad. Jose ("Joe") Wo is behind her. Ysabel is in the center of the group of women on the right. Victoria, who has a friend's arm draped over her shoulder, is on the left. (Comaduran collection.)

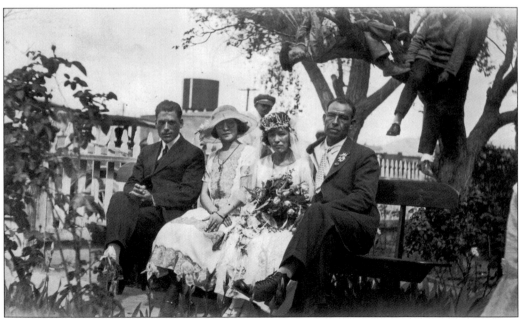

Soledad Wo sits between the unidentified groomsman and her sister Lecha, the bride. The boys are still clowning it up in the tree. The Wo house was directly behind their store, on the corner of Gila and Fifth Streets, across from the Catholic church. (Comaduran collection.)

The four sisters were united once again when Dario Castillo met an early death. They lived together in the house on Fifth and Gila Streets, along with Lecha's two little girls, Loretta ("Toto") and Imelda ("Mella"). From left to right are Soledad ("Sole"), Ysabel ("Chavela"), Victoria ("Vicky"), Loretta, and Felicia ("Lecha"). Their nicknames were as well known as their given names. (Comaduran collection.)

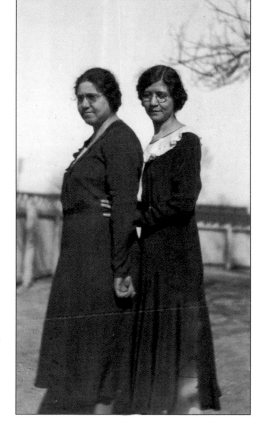

Soledad (right) and her mother Emetria Wo bear a resemblance to one another. Hi Wo took Soledad out of school at age 14 to take the place of his bookkeeper, who had married. She later earned a GED. It is said she was a math whiz and could add three-digit figures in her head almost as quickly as she could get the answers on the abacus. (Comaduran collection.)

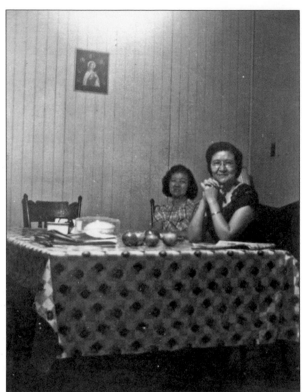

In later life, Soledad (right) and Ysabel (left) tended the store. Here they are after a day's work, relaxing at the kitchen table. The house was directly south of the store. (Comaduran collection.)

Albert Comaduran (left), son of Josephine Comaduran and Joe Wo, poses with his mother, Josephine King, and half-siblings, Patsy and Bob King. The Kings grew up in California, but Albert lived his entire life in Benson. (Comaduran collection.)

Three

THE HUB CITY

Benson came to be known as "The Hub City" because three railroads met there. From Benson, people turned south to the mining towns of Tombstone and Bisbee or to the international ports at Nogales and Douglas. To the east were New Mexico and Texas, and west were Tucson and California. Fourteen hundred pounds of copper ore a day was shipped out, supplies were shipped in, and people went every which way. Benson served the Tombstone, Bisbee, Dragoon, Yellowstone, Rincon, Huachuca, and Whetstone mining districts, and ranching needed the railroad's services as well.

In March 1880, the *Tombstone Maverick* scoffed at the idea of Benson, ridiculing what it called "little enthusiasm over the matter" of the railroad's selling of 64 lots and at attempts to bring up water from a well. But Benson developers did find water, plenty of good artesian water. By 1895, there were 350 such wells in and around Benson, no doubt the envy of places like Tombstone.

Benson was laid out with north-south streets named after local mountain ranges and rivers and east-west streets numbered one through nine. Fourth Street between Gila and Patagonia Streets became the business district. Hotels, liveries, retail stores, a post office, a lumber yard, restaurants, and, of course, saloons were quickly established. Travelers in the early 1900s noticed the town of 1,100 people bustling with cowboys, miners, railroaders, and local gentry of all races.

Law enforcement was sporadic during the early years. A town constable and his assistant were essentially the only town employees. One of them worked days, the other nights. The nighttime shift was more difficult and paid more. On one occasion, however, Benson citizens took matters into their own hands and stormed a saloon known as the Joint to expel from it, and from the town, a band of outlaws known as the Top and Bottom Gang, who had shot a sheriff's deputy. They dismantled the saloon and gave the gang until sundown to leave the town. The gang moved on to Tucson that evening.

Though the railroads left beginning with Santa Fe in 1898, Benson survived this and many setbacks by virtue of its ideal location. It remains a terminus of traffic from the south and an oasis from the monotony of travel.

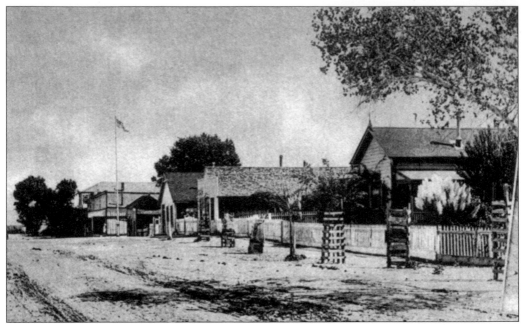

This pre-1900 view, looking east down Fourth Street from Patagonia Street, reveals the Grand Central Hotel, the Virginia Hotel, and the sloped roof of the Bathshop (25¢ for a hot bath). The flag probably marks the home of Leonard Redfield. Wooden barriers built around trees may have been to protect them from animals.

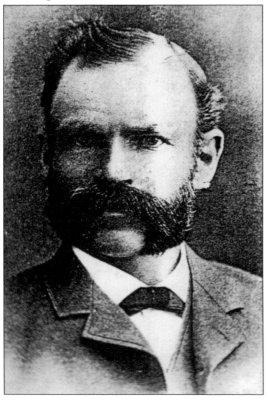

Lumber store owner Herman Gerwein opened Gerwein and Bullis Lumber Company east of Patagonia Street in 1880. Gerwein died in 1909.

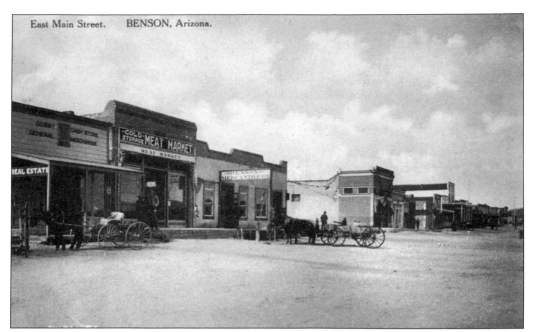

Fourth Street bustled with activity in the early 1900s. The real estate office in Cosby's Cash Store (left) says much about the boom times. At the center is the Maier Brothers Store, on the corner of San Pedro Street, which burned in 1921.

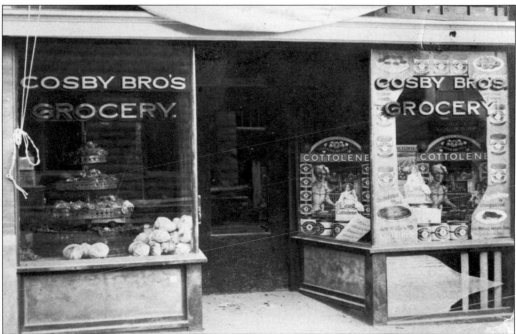

Cosby Brothers Grocery, also known as Cosby's Cash Grocery, in the block east of San Pedro Street, was named for James Melvin and John Robert and sold everything from produce to real estate. After Alvah Fenn and his family fled Mexico on the train in 1912, spending their last $5 in Tombstone in a vain attempt to save their baby, James Cosby helped them get on their feet when they got off the train.

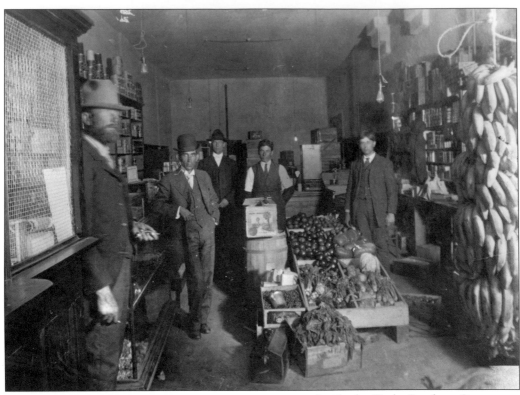

Inside the Cosby Brothers Grocery, men gather, perhaps to resolve important matters concerning Benson. The bananas undoubtedly came by train, but much of the other produce appears local in origin.

COSBY CASH STORE
GENERAL MERCHANDISE

We Make a Specialty of Fresh Ranch Products.

Dry Goods
Notions
Boots and Shoes
Honey
Staple and Fancy
Groceries
Fruits in Season
Cigars and Tobacco

BENSON, ARIZ. Nov. 12. 1903.

This is to certify that I have this day sold to Mrs. A. C. Comaduran 1 Cow & Calf Branded 1X on left side ∇+ on left Thigh. For the sum of $45.00. It is also further provided in this agreement, that I turn the cow over to J. M. Cosby until she is paid for. The provisions of the purchase being $25.00 Cash and $20.00 Balance to be paid on or before the 10th day of December 1903 to the said J. M. Cosby who shall then and there deliver this Bill of Sale and agreement to the said Mrs. A. C. Comaduran. Failing to carry out the provisions of this bill of sale Mrs. A. C. Comaduran to forfeit the said $25.00 that she has paid.

Witness
K. M. &c.

T. Bricken

On November 12, 1903, Mrs. A. G. Comaduran bought a cow and calf with brands from local ranches for $45. The bill of sale, on Cosby Cash Store letterhead, was drawn up by T. Bricken, perhaps an early lawyer. (Comaduran collection.)

Citizen's Bank, established March 1905, was located just west of Huachuca Street, next to the new post office. A bank has continuously occupied the site ever since, though its ownership has changed often.

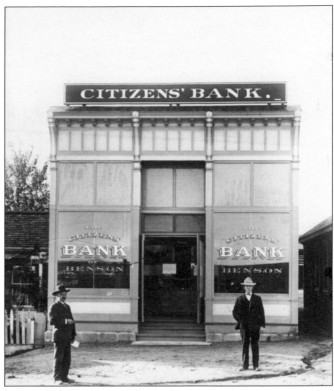

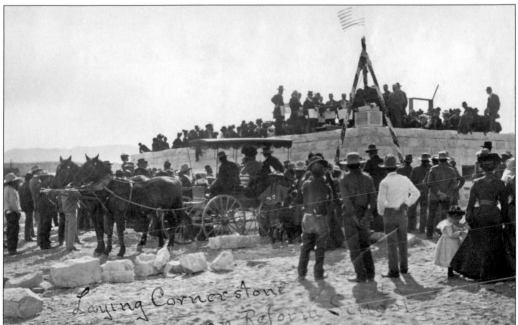

It looks as though the whole town came out to watch the laying of the corner stone for the Territorial Industrial School, built in 1902 and opened in 1903 in Benson at a cost of $25,000. It would be another year before the building was furnished, however, and delinquent boys could be referred there. (Arizona Historical Foundation.)

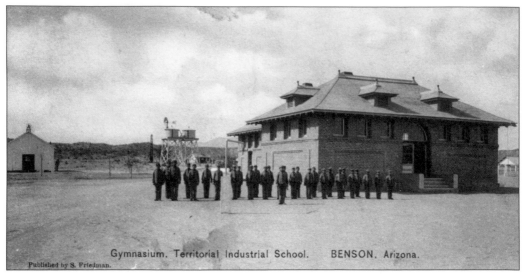

A few years after the original dormitory/classroom was built, a gymnasium was added to the Territorial Industrial School for another $25,000. The gymnasium provided a staging place for military-style drills of the boys. Such regimentation mirrors Native American boarding schools of the same era.

A building on Fifth and San Pedro Streets served as the first school. Formerly a church, the building had been moved from west of Benson to Fourth Street, where it sat among taverns. Nobody liked that arrangement, so the building was moved to this location on San Pedro Street. Later on, the Women's Club owned it, and when their new building went up, they used the former school as a library.

The first post office was built soon after Benson was established in 1880 in the block between Huachuca and San Pedro Streets. The first postmaster was John Russ. Pictured here, at the new post office west of Huachuca, is Leonard Redfield, who became postmaster in 1896, with employee Laura Martinez and an unidentified woman and child (perhaps Redfield's wife and child).

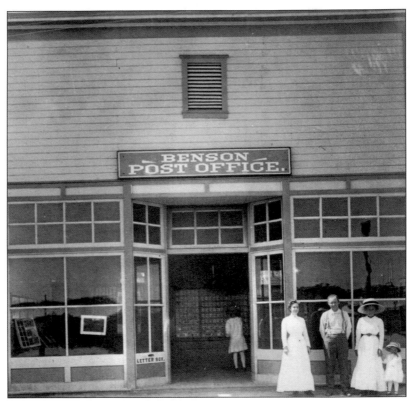

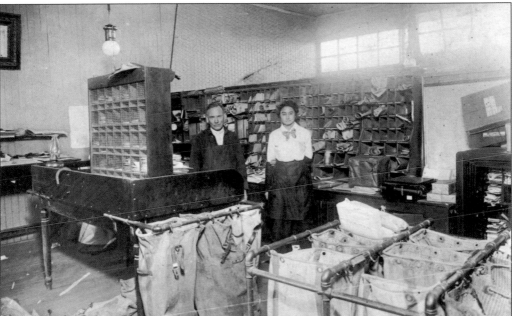

Leonard D. Redfield and Laura Martinez work behind the scenes at the post office. Leonard's father, Henry Redfield, was postmaster in Redington, downstream north on the San Pedro River, and as a boy, Leonard carried mail by horseback to communities up and down the San Pedro Valley. Redfield later became Benson's first mayor.

Near the post office was the Goldwater Store. However, the letterhead on this receipt to M. Moreno has been stricken through and another merchant's name written there, illustrating that recycling/reuse was an important part of territorial business. (Comaduran collection.)

Numerous wells dug in the 1890s provided a means for everyone to buy their water rather than dig their own wells. Still, as this bill dated March 1, 1909, shows, conservation was encouraged. Sharing with your neighbor was strongly discouraged—let them subscribe themselves. Mr. Cosby probably owned the well, and the Bank of Benson collected the fee. (Comaduran collection.)

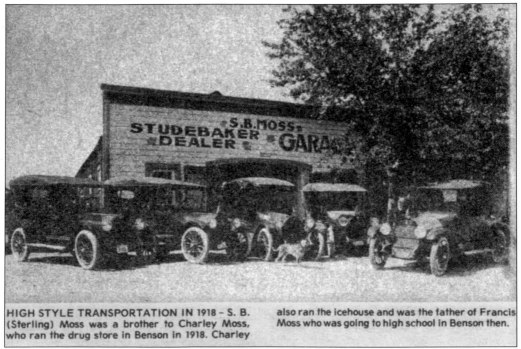

HIGH STYLE TRANSPORTATION IN 1918 – S. B. (Sterling) Moss was a brother to Charley Moss, who ran the drug store in Benson in 1918. Charley also ran the icehouse and was the father of Francis Moss who was going to high school in Benson then.

S. B. (Sterling) Moss got into the automobile business early, selling and servicing Studebakers in 1918. He also ran the icehouse from a different location.

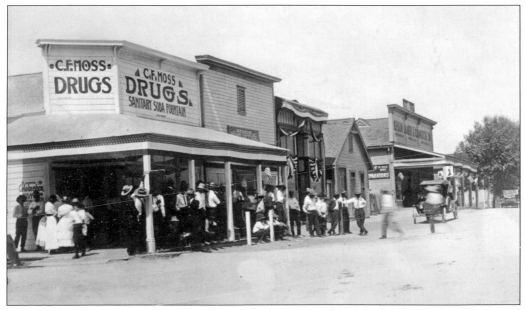

Benson people seem gathered for a parade on Fourth Street in the 1920s, but the parade is comprised of only one car. C. F. Moss Drugs at the corner of Huachuca and Fourth Streets is next to the post office, and then the bank, with Benson Lumber Company at the far end. C. F. (Charlie) Moss served on Benson Union High School District's first board of education.

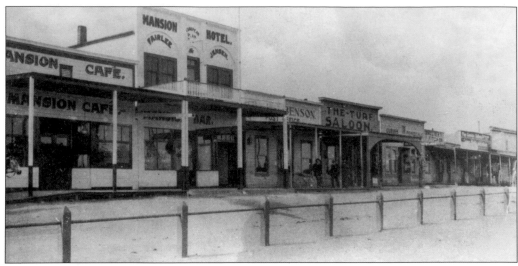

The two saloons in this block between San Pedro and Huachuca Streets in 1910 no doubt kept the nighttime constable busy, especially the Turf Saloon, which townspeople dismantled when they evicted the Top and Bottom Gang. Next door, the Bank of Benson was also the first post office. On the right is the Virginia Hotel, owned by A. A. Casteneda, where Pres. Benjamin Harrison had lunch on April 21, 1891. The Mansion Hotel, next, was still operating in 1930, as evidenced by a letter from a traveler looking for work. No doubt many such travelers were on the roads in early 1930s, having no better luck than this chap. It is interesting that he speaks of work in Mexico. Working across the borders seems to have been entirely acceptable at this time.

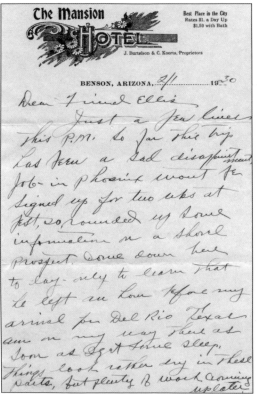

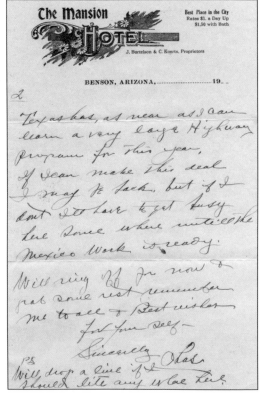

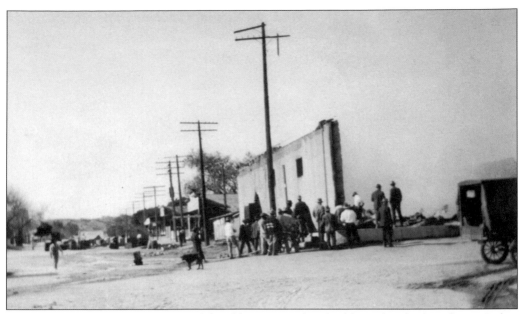

Townspeople look at the wreckage of the old Maier Brothers building after the fire of 1921. Before electricity, wood stoves and kerosene lamps caused many fires, though the cause of this one is unknown. This is also a rare look at the side street, San Pedro Street. The building on the next corner is now home to the San Pedro Valley Arts and Historical Museum.

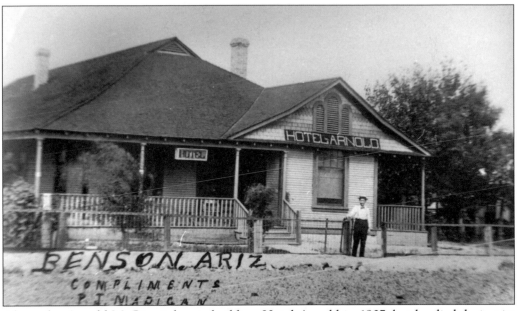

Alexander Arnold McGinnis began building Hotel Arnold in 1907, but he died during its construction. His wife, Nora, and her brother P. G. Madigan (pictured) operated the hotel for many years. Made of redwood, this building still stands.

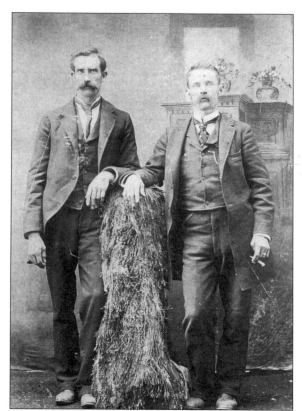

Dr. Henry Watkins (right) poses with his brother George, an engineer, in 1890. Dr. Henry and Sallie Watkins came to Benson for their health in 1897. Both energetically joined the Benson community and were much loved, especially Sallie, for her charity toward others. Dr. Watkins died in 1903, and Sallie died in 1908.

Henry Walker stands before his pharmacy, built between San Pedro and Huachuca Streets prior to 1889. The adobe building did not survive fires and face-lifts, but the site was later occupied by Cooper Drug, then Joe and Ed's Place, owned by Joe Quihuiz and Ed Ohnesorgen in 1935. In 1969, it was known as Joe's Confectionary, run by Luz Quihuiz.

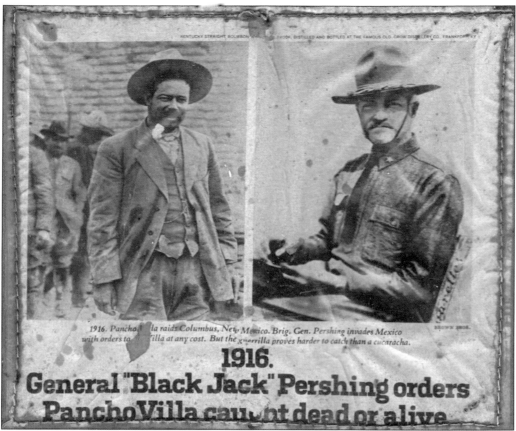

1916. Pancho [Vi]lla raids Columbus, New Mexico. Brig. Gen. Pershing invades Mexico with orders to [catch V]illa at any cost. But the guerrilla proves harder to catch than a cucaracha.

1916.
General "Black Jack" Pershing orders
Pancho Villa caught dead or alive

During the Mexican Revolution, sentiment in many Benson homes was with Pancho Villa. The caption of this newspaper article, covered and stitched to a piece of cardboard in an effort to preserve it, reads, "The guerrilla proves harder to catch than a cucaracha" (cockroach). Gen. Jack Pershing pursued Pancho Villa into Mexico following Villa's raid in Columbus, New Mexico. (Comaduran collection.)

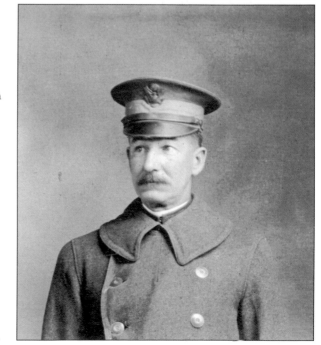

In the First World War era and into the 1920s, Dr. Richard Yellot helped answer the medical needs of Benson.

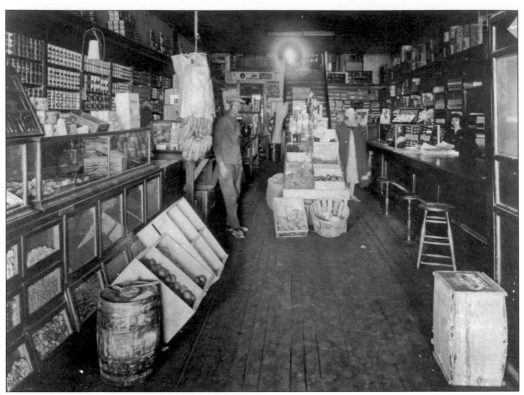

Hi Wo Grocery operated from 1896 until 1989. Hi Wo stands to the left, while daughter Soledad stands behind the counter. The customer is unidentified. Soledad and her sisters ran the store after Hi Wo died in 1931.

From left to right, Jose ("Joe") Wo, stands with his sisters, Felicia (Lecha) and Soledad (Sole). Joe later married a Chinese girl, as arranged by Hi Wo when Joe was a young boy. The married couple lived in Phoenix.

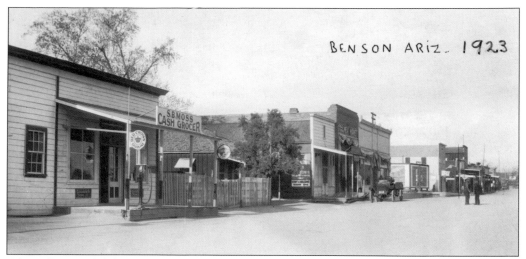

After selling Studebakers, S. B. Moss also sold Red Crown gasoline to early automobile traffic from this store east of San Pedro Street. Two doors down is the K&H (Kempf and Holcomb) Grocery.

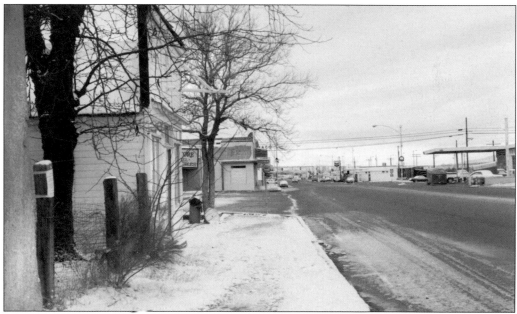

The block that formerly had Moss's gasoline station looks much different in 1960. The Moss building is gone from where the street is recessed. In fact, a new post office (out of view) occupies part of the recessed space, and McGoffin's Furniture opened where Moss once sold gas. The photographer was standing in front of Hi Wo Grocery.

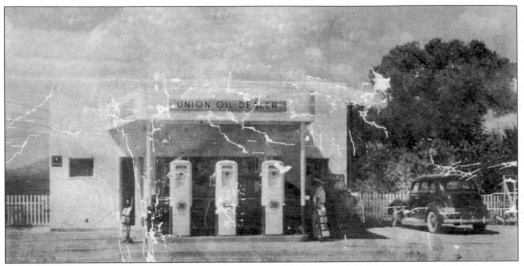

Across the street from Moss, Lee Granthan opened a Union Oil filling station. This building (though not the business) survived into the 1990s.

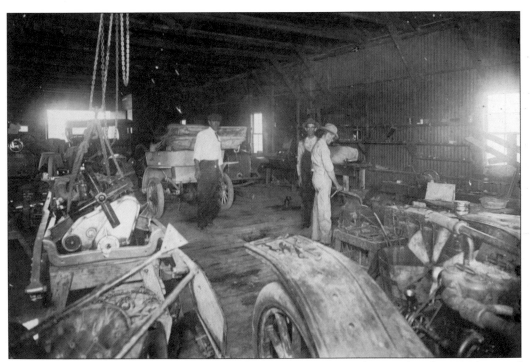

Someone has to fix the autos when they break down. Pecos Garage (pictured in the 1920s), owned by W. F. Jones and M. H. Davis, was one such place. Mechanics often had been blacksmiths prior to the automobile.

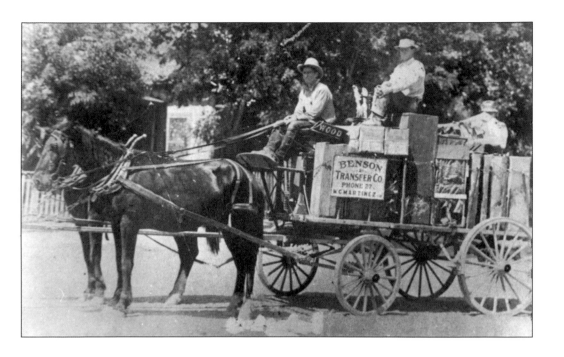

Despite the rage in automobile travel, horses and wagons still dominated the transportation scene. This freight wagon, owned by W. C. Martinez, is driven by Alvah Fenn. The wagon seems homemade, with carriage wheels. To hire this rig, one only had to dial 27 on the phone. Alvah Fenn had established himself as a wagoner while driving the school bus when Benson and Pomerene formed the Benson Union High School District in 1914. (Both images, Museum.)

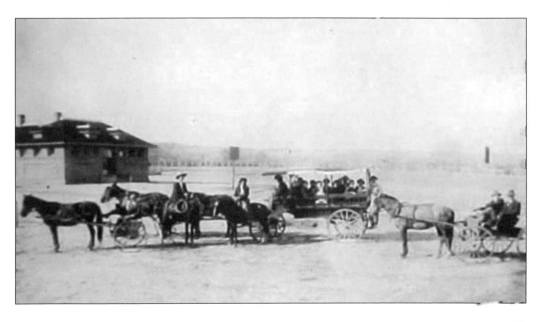

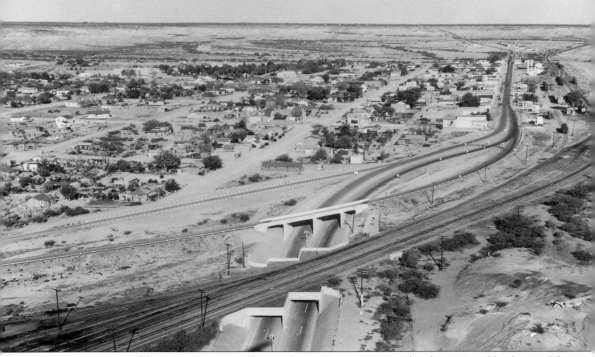

The 1940s would see development of a new form of interstate travel—the national highways. This preview of Benson gives perspective to how the intersection of railroads and the development of highways would continue to shape Benson.

Four

HOME ON THE RANGE

Ranching played an important part in developing the San Pedro Valley. Early explorers reported vast plains of grasses suitable for many head of cattle. The cattle and horses needed for Fort Huachuca and mining towns were pastured from mountain range to valley floor.

The earthquake of May 3, 1887, centered in the San Bernardino Valley of Sonora, southeast of Douglas, Arizona, resonated throughout the San Pedro Valley. Early settlers throughout the region reported hot rocks and fire spewing from fissures in the ground both in the mountains and in the valleys, igniting the abundant grasslands. Annual torrential rains, called monsoons, began a few weeks later, ripping the unprotected earth apart with erosion. Tens of thousands of head of livestock perished, either in the fires or of starvation during the aftermath.

By the mid-1990s, over 350 artesian wells had been brought to production in the valley around Benson, producing some of the purest water to be found in the state. Irrigation and rainfall were enhanced by this ready supply of water, and agriculture grew in importance. Improved irrigation techniques through the decades brought agriculture to its zenith.

Ranching and agriculture rose in importance after the railroads moved operations to Tucson in 1911. Many ranching families came from Texas. The mountain pass east of Benson is named Texas Canyon for all the Texans who settled there. Ranchers of Mexican descent were still active as well. A rodeo was established in 1930 to celebrate the cowboy culture. Although subject to fits and starts, the rodeo still operates today.

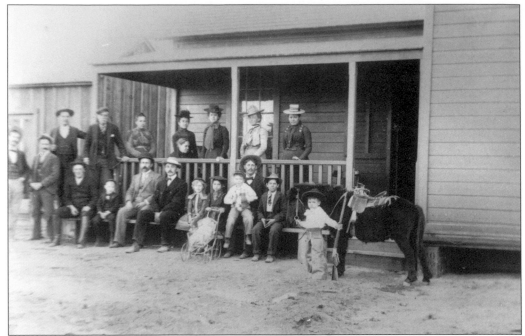

This early Castaneda family gathering around 1900 shows a large family of ladies and gents dressed in their traveling clothes and children of all ages. The most riveting character is the serious young man with pony and rifle standing before the steps. Kids grew up quickly on the range. Joel Miguel (née A. A.) Castaneda owned the Virginia Hotel.

A beautiful woman despite her simplicity of dress, Jesus Mendez de Pacheco married Marcos Pacheco Sr. and bore him eight children. (Comaduran collection.)

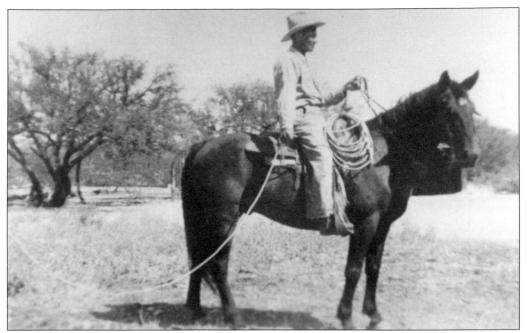

Marcos Pacheco Jr., fourth son of Jesus and Marcos's six boys, was a rancher born and raised. He probably lived most of his life on a horse. His daughters, Juanita and Lucrecia Pacheco, operated the ranch near Tres Alamos in the next generation. Marcos was also an early town constable. He used a bullwhip to chase people home at curfew time. (Comaduran collection.)

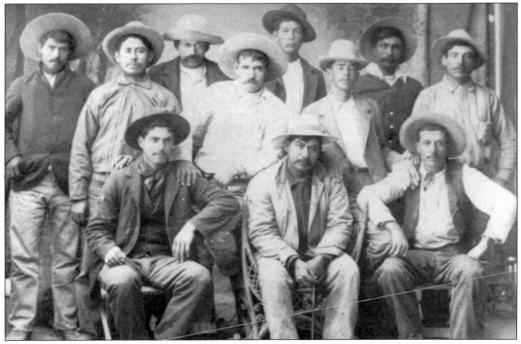

This band of handsome cowboys at Tres Alamos includes (standing) Carlos Duarte, Jubacio Duarte, four unidentified, Ramon Mendoza, and Arturo Grijalva; (seated) Pedro Leon, Marcos Pacheco Jr., and unidentified. (Comaduran collection.)

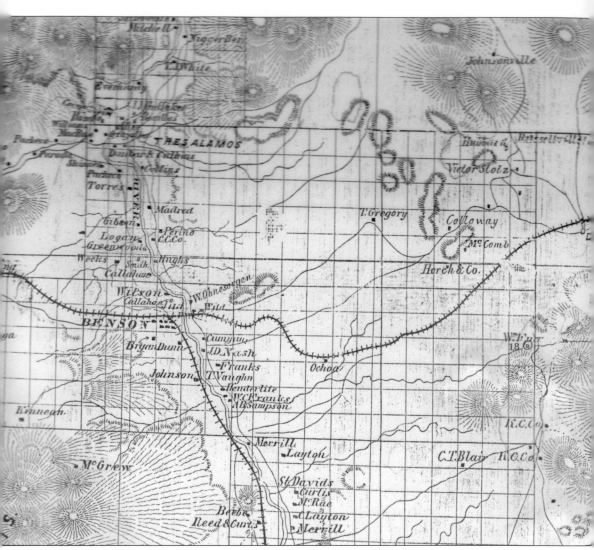

Mexican pioneers found the San Pedro Valley suitable for ranching long before the Americans arrived. Many contests for ownership followed the Homestead Act of 1862, not always with the fairest outcome. Mexican families were at a disadvantage because of language barriers and access to legal representation.

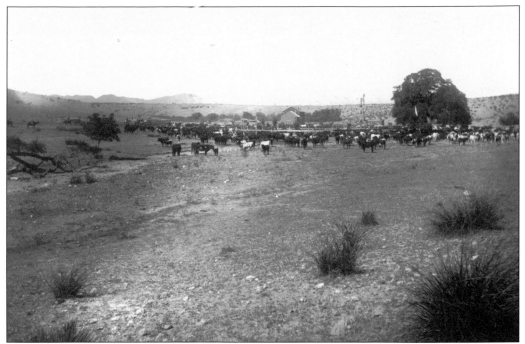

Noted territorial photographer C. S. Fly took this picture in 1887. Devastation to the valley's topography after the 1887 earthquake resulted in the demise of 50,000 head of cattle either by fire or starvation. (Arizona State Library, History and Archives Division, Phoenix, 97-2610.)

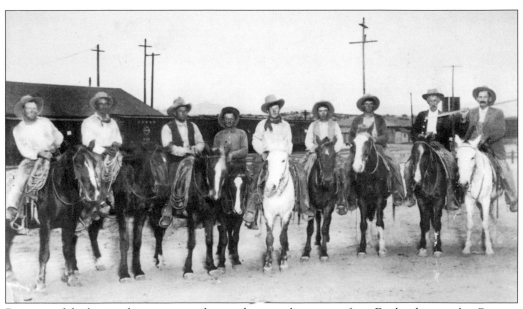

Presence of the livestock inspector indicates these cowboys, most from Fairbank, paused in Benson after herding some livestock to the stockyards. From left to right are Ben Stein, Tom Ogals, and Henry Jones of the Wagon Rod Ranch, Fairbank; Walter Johnson of Johnson and Cook, Willcox; Rollen Curry of Hereford; Roy Harman, Vinnie Adams, and Sam Wilson of the Wagon Rod; and Peter McDonald, livestock inspector, in front of Billy Binnets [sic] Store in 1912.

The Getzwiller boys, from left to right, Herndon, Willis Joe ("Jinx"), and Pierre, would inherit sizable ranch lands near Benson. The Spear-G ranch west of town remains in possession of the Getzwiller family.

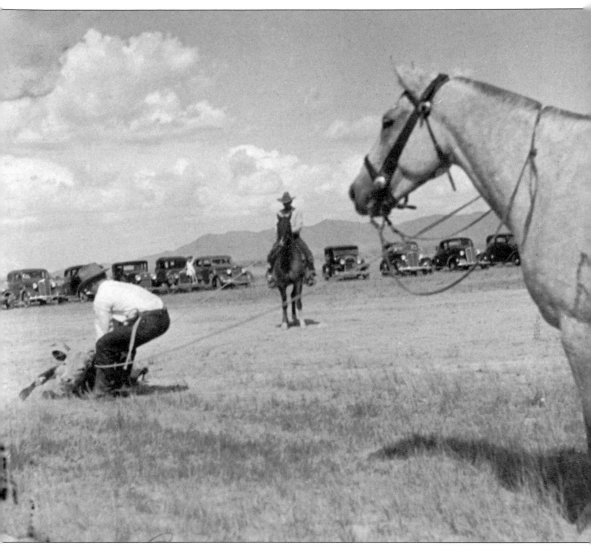

The first rodeo arena in Benson was a ring of automobiles belonging to the observers. From this humble beginning grew a circuit-standard rodeo that brought hundreds of guests to Benson twice a year. The newspaper in 1941 crowed about the rodeo: "bigger and better than ever."

Mr. Gonzalo Barrios models the typical cowboy hat essential to a life in the sun.

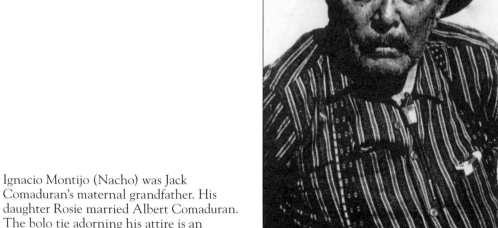

Ignacio Montijo (Nacho) was Jack Comaduran's maternal grandfather. His daughter Rosie married Albert Comaduran. The bolo tie adorning his attire is an Arizona invention. (Comaduran collection.)

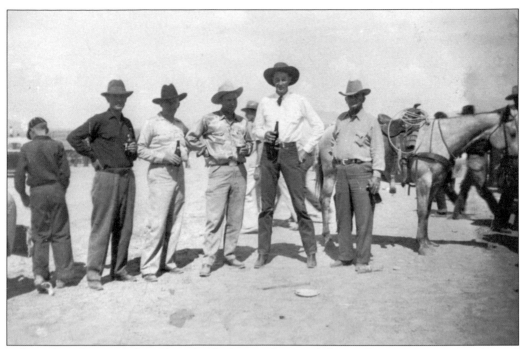

A line of cowboys partake of liquid refreshment during a lull in rodeo action. Page Lee, located third from the right in this *c.* 1940 photograph, provided the beer.

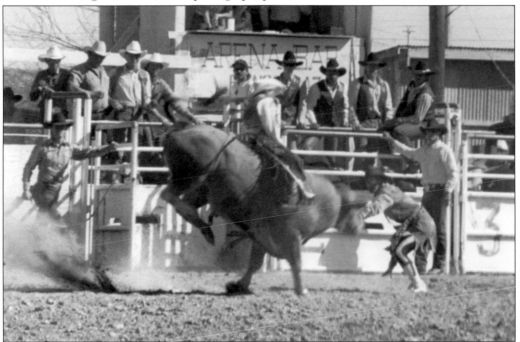

By the 1960s, a real rodeo arena had been in use for some time. Located west of Benson, the San Pedro Valley Rodeo provided entertainment for everyone, resident and tourist alike. Stockmen provided the animals, such as this muscular bull, and the winning cowboys gained credit in the circuit for skills displayed in Benson.

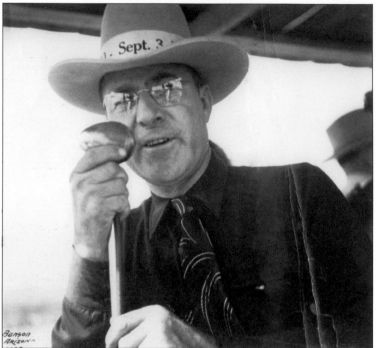

Rodeo announcers such as Bill Emmons contributed their talent on the rodeo circuit. We can almost see the rodeo in this announcer's glasses.

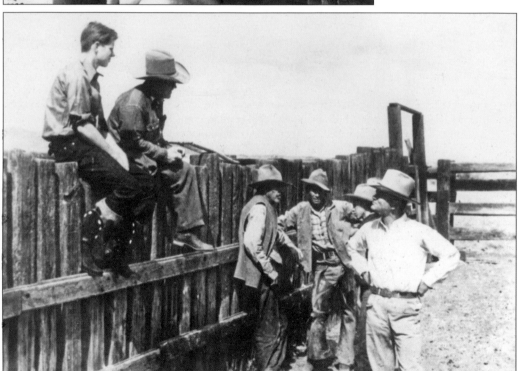

That young cowboy on the fence is Jack Kennedy. He and his brother Joe (not pictured) spent a summer on Jack Speiden's J-Six Ranch west of Benson in 1936 to toughen up before a hard season of sports at Harvard. Speiden stands with arms akimbo. On the fence beside Jack is Pete Haverty, a successful rodeo cowboy despite having lost one leg. (Virgil Haverty and Stan Benjamin.)

Five

SCHOOLS, CHURCHES, AND RECREATION

Perhaps nothing does more to establish civilization in a new country than the beginnings of schools and churches. As people become more at ease with their surroundings, favorite forms of recreation begin to develop as well. Together these shape and define the culture of a place.

One of the first schools in Benson was in a building that had been moved from some distance out of town to Fourth Street and then farther into the residential area south of Fourth Street. A church at first, it later served as a school. Benson people erected a more substantial building on the corner of Sixth and San Pedro Streets. Two additions were made to the building, which sheltered students from the 1890s until 1927.

The next school, the Territorial Industrial School for Boys, was built by Arizona Territory at a location southwest of the business district. Surrounding the school were fields in which crops were planted and harvested by the boys. In 1913, this reformatory-type school was moved to Fort Grant in the Sulphur Spring Valley, and the town acquired the buildings to use as a middle and high school. The first class of high school students graduated in 1915. The buildings were used until 1929, when a new high school was built. A new grammar school was designed and built in 1927 by famed Tucson architect Josias Thomas Joesler. Both buildings were demolished in the 1980s.

Our Lady of Laurdes Catholic Church, which Edward Ohnesorgen helped build around 1890, was the first church built in Benson. The Presbyterian church, later the Community Presbyterian Church was built in 1905. Pomerene supported the Church of Jesus Christ of Latter-day Saints (Mormon), and other churches later joined the list. Church events comprised much of the social life for all denominations.

Picnics and outings to the Chihuahuan desert region surrounding Benson and nearby mountain ranges entertained residents and visitors alike Many dude ranches could be accessed from the Benson depot as the train continued to play a part in Benson's economy. Parties, school activities, and social groups all contributed to the cultural depth of Benson.

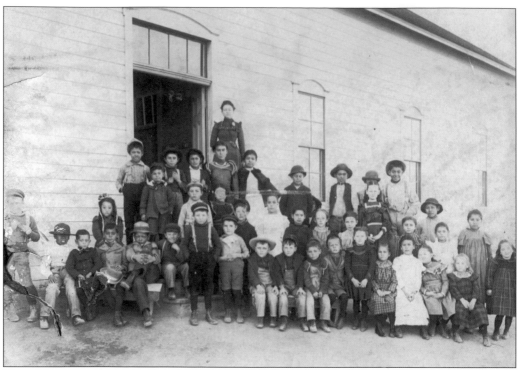

This group of schoolchildren in 1905 includes children of all ages but apparently only one teacher. Perhaps that explains her stern expression.

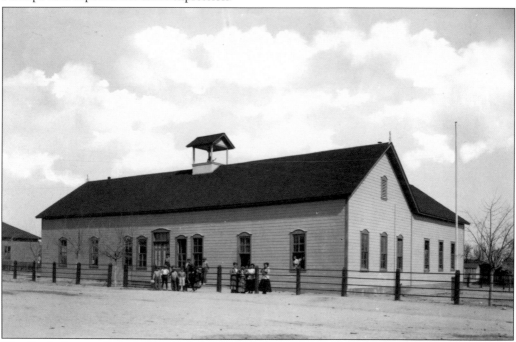

The Sixth Street school was really quite large after the addition at the back and another on the other side. Notice the change in window dressing. (Arizona State Library, History and Archives Division, Phoenix.)

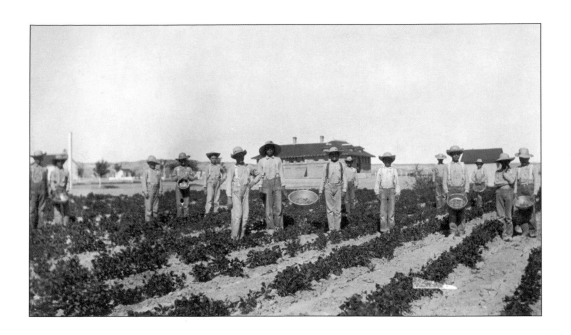

These boys from the Territorial Industrial School proudly pose displaying their crop, which appears to be beans. The gymnasium in the background sat a little farther south than the main building. Engrossed in their work, the boys leave a clearer view of the gymnasium and the western ridge of hills behind Benson. The building to the left may have been a barn, and water towers mark an artesian well that served Benson schools for many years. Built in 1902, the school operated in Benson from 1903 until 1913, when it was moved to Fort Grant. (Both, Arizona State Library, History and Archives Division, Phoenix, 95-2785 and 95-2786.)

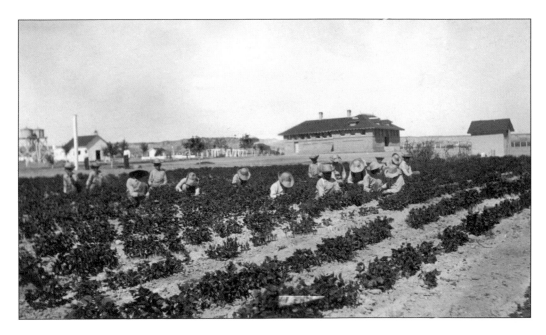

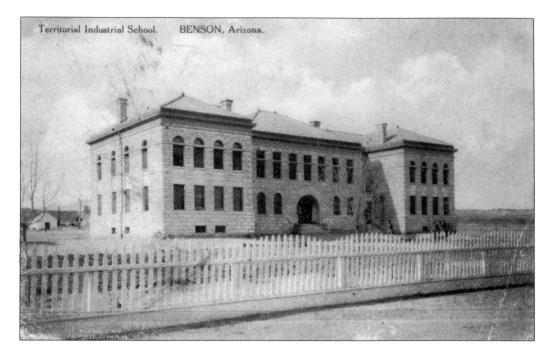

Territorial Industrial School. BENSON, Arizona.

The Territorial Industrial School in its austere beginnings may have seemed ominous to the boys brought here for remediation. The white picket fence appears out of place against the stark limestone-block construction. In later years, however, trees and other greenery mitigate the stark outlines of the building. Some impressive stonework and design are evident in a closer view of the building's construction.

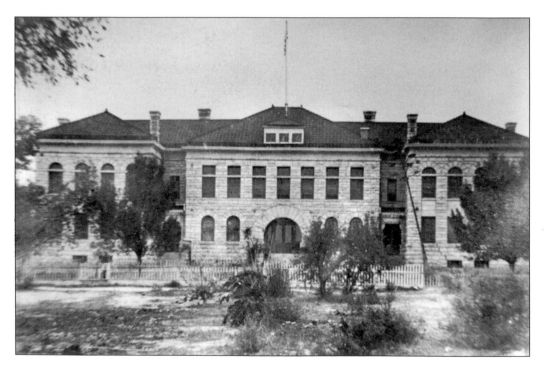

The school at Sixth and San Pedro Streets continued in operation for many years. This view in the early 1900s looks west up Sixth Street. The front of the school faced south.

The teaching staff, expanded to meet Benson's needs in the new century. The staff included five teachers by 1907: (from left to right) Mrs. Burke, Miss Duke, Miss Pyne, Miss Phelps, and Miss Thompson.

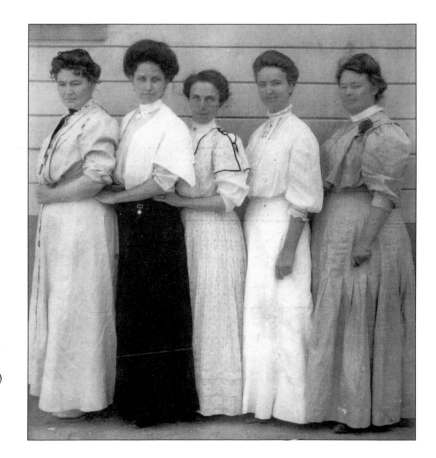

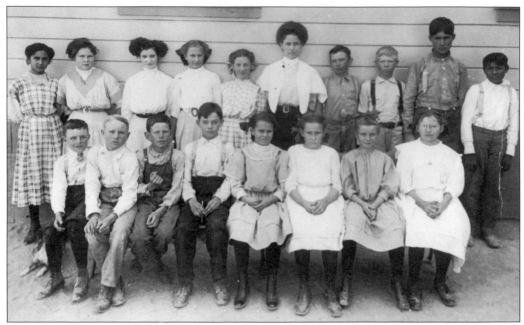

Though some Benson Grammar School students in 1908 may not have had ties or ribbons, all were spit-and-polish clean for their school picture. Pictured, from left to right, are (first row) Willie Guess, Willie Etz, Stanley Houston, Harold Gribble, Marguerite Shilliam, Lena Horton, Ruby Spear, and Marie Harmon; (second row) Beatrice Ohnesorgen, Carrie Clark, Bessie Bock, Alice Bradford, Anna Houston, teacher ? Duke, Roy Harmon, Roy Short, Willie Martinez, and Claudio Mendivil.

After the Territorial Industrial School abandoned the buildings southwest of town, Benson and Pomerene formed the Benson Union High School District. The first BUHS Board of Education members were H. S. Etz, H. P. Merrill, C. F. Moss, M. P. Cosby, and D. C. Neagle. There were three high school graduates in 1915: Genevieve Theoroux, Marie Harmon, and Bearl Neagle.

Some of the children in the class of 1920 have no shoes. This was just after World War I, and commodities, as well as disposable income, may have been in short supply in Arizona.

Benson's first school bus was a horse-drawn wagon that seated about a dozen. For many years, it was on display as seen here on the high school campus. Today it is housed at the San Pedro Valley Arts and Historical Museum.

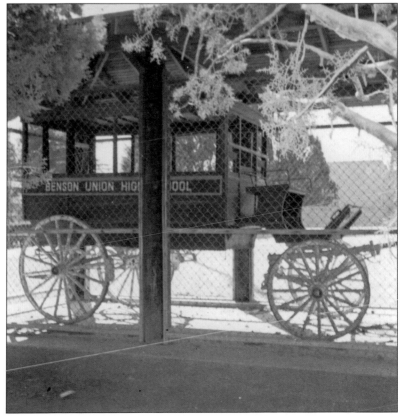

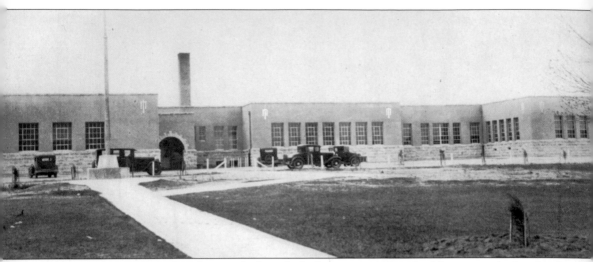

In 1929, after passing a bond issue, the board of education set about building a new high school building. Some of the stones from the Territorial Industrial School building were used to construct the new high school. The auditorium on the east end of the school (left) had a raked floor. This building was torn down in 1983 after being mildly affected by an arson-set fire.

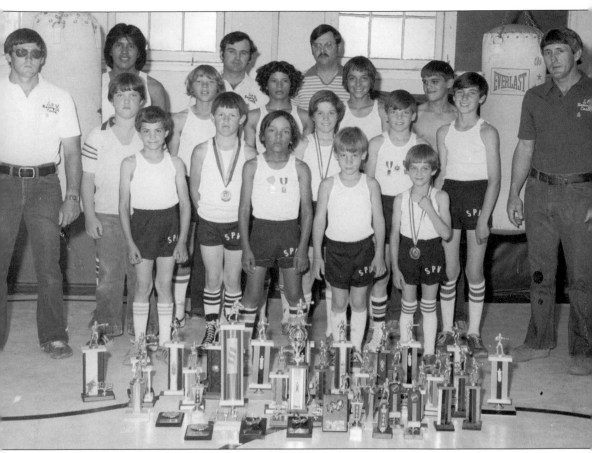

Moving forward to the 1970s, the San Pedro Boxing Club exhibits their medals and trophies following a season of competition. Though short-lived, the boxing club appears to have been quite successful. Those identified are, from left to right, (first row) Lason Barney, Donnie Fenn, unidentified, ? East, and Danny Barney; (second row) unidentified, Mike Hagerstrand, Danny Telles, Rick Sherman, ? Dimas, Mike Sherman, Nephi Judd, and unidentified; and (third row) Pat Young, unidentified, Barry Sherman, Dan Tibbetts, and Tom Young (far right).

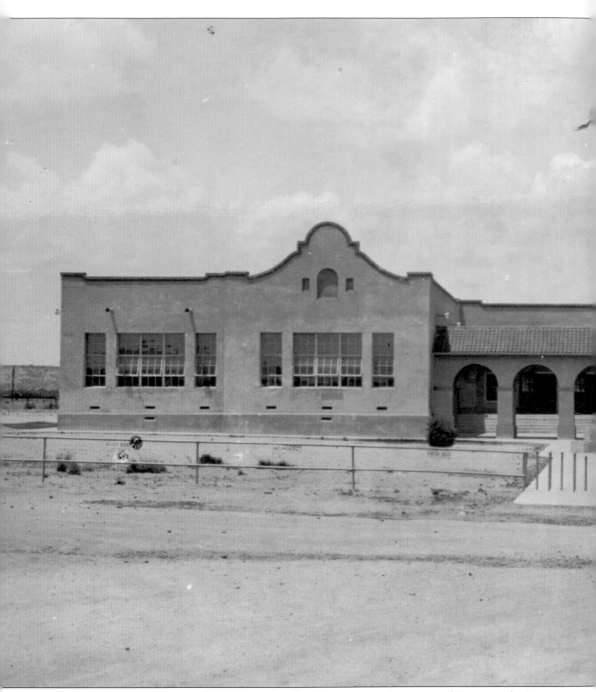

Truly a work of art and the best piece of architecture ever to have graced Benson, the Benson Grammar School was designed and built by noted Tucson architect Josiah T. Joesler in 1926. The

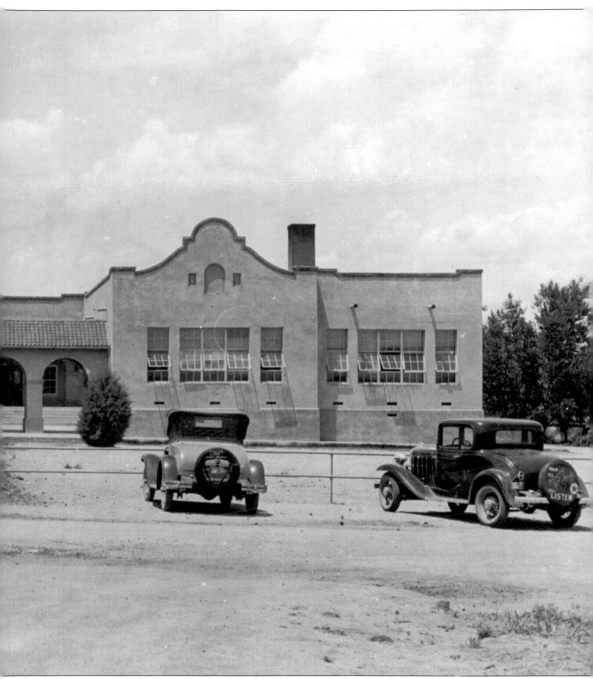

mission style of architecture was a hallmark of Joesler. Benson has demolished many of its best buildings, and this is no exception, having been razed in the early 1980s.

Alice Sabin (left) was an early Pomerene schoolteacher.

Pomerene's first school cost $700 to build in 1913. It was demolished in 1940.

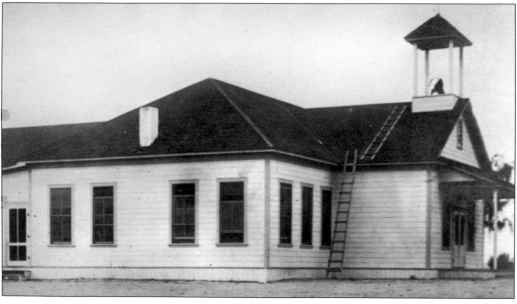

The first Catholic church in Benson, built in 1895, served the Catholic community for worship for 53 years and was used as a parish for 20 years after that.

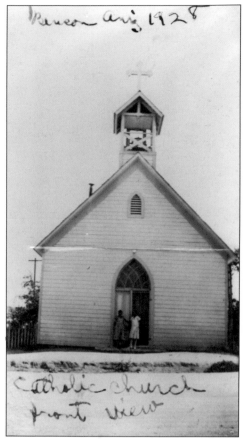

Benson ariz 1928

Catholic church front view

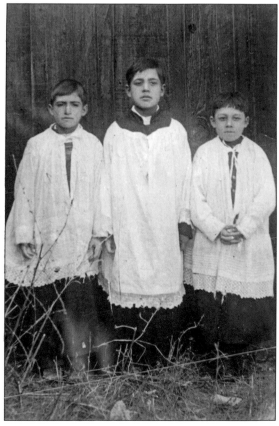

Altar boys, from left to right, Paul Blanco Jr., Antonio Meza, and Albert Comaduran appear to take their responsibilities seriously in the early 1920s. (Comaduran collection.)

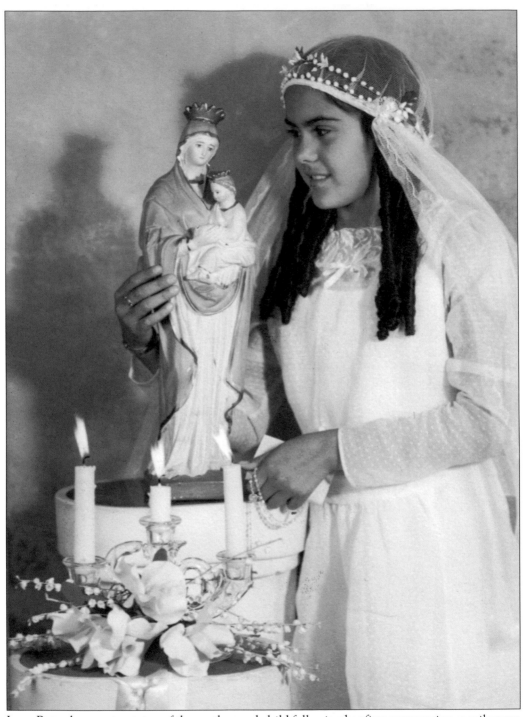

Lupe Bernal gazes at a statue of the mother and child following her first communion, a milestone in her religious life.

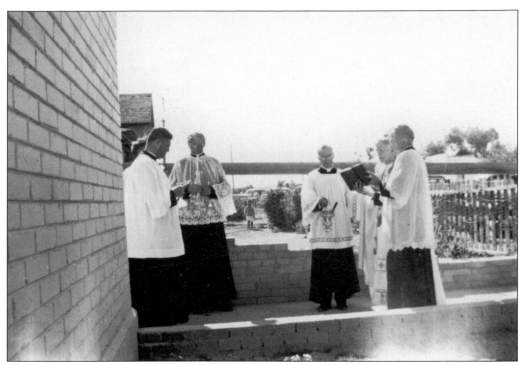

The Catholic congregation outgrew the first humble church, and a new Our Lady of Lourdes Catholic Church was blessed on May 22, 1949.

Snow day in the Wo's front yard gives a good view of both Catholic church buildings. The older church was torn down eventually to make room for a church office and fountain. (Comaduran collection.)

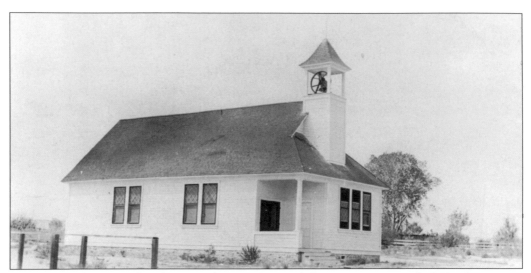

The first Presbyterian church, erected in 1905, served the community until 1940, when it was damaged by fire.

A new Community Presbyterian Church on a hill at the south end of Huachuca Street replaced the damaged older church. This new building offered a recreation room that answered a need in Benson for a roomy place to gather.

A SNOW STORM IN BENSON, ARIZONA.

Showing they could invent a good time, Dr. Richard Yellot and family crafted a makeshift sleigh by which to enjoy an unusually heavy snowfall around 1915 at the corner of Fifth and San Pedro Streets.

Mrs. Powell, wife of Dr. Charles Powell, poses on an outing in 1937 to Chiricahua National Monument, or "Wonderland of Rocks," in the Chiricahua Mountains southeast of Willcox.

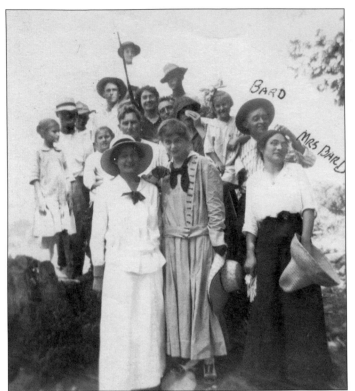

A merry group of recreationists includes "Bard" and "Mrs. Bard" and their smiling daughter. A. W. (Allie) Bard and his wife, Mary, owned Bard Haberdashery and Barber Shop, and both Allie and Mary were active in Benson for 25 years before moving to Blythe, California, in 1934.

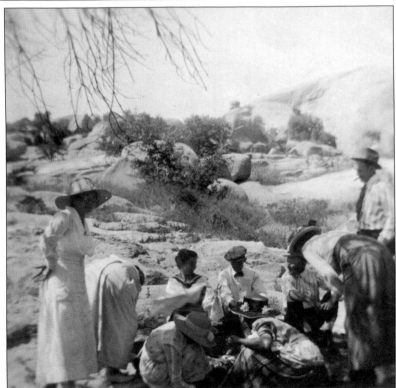

Picnics in Texas Canyon, 15 miles east and 1,200 feet higher than Benson, provided a cool respite from summer heat.

Eight girls, including some Wo sisters, enjoy an outing to gather prickly pear cactus fruits for jelly. Called tunas, the fruits are just as prickly as the cactus, but the jelly made from them is worth the trouble. (Comaduran collection.)

The Cochise County Concert Band of the early 1900s included Joe Wo (second row, last clarinet), Ben Caballero (back row, right of tuba), and Paul Blanco (back row, third from right). (Comaduran collection.)

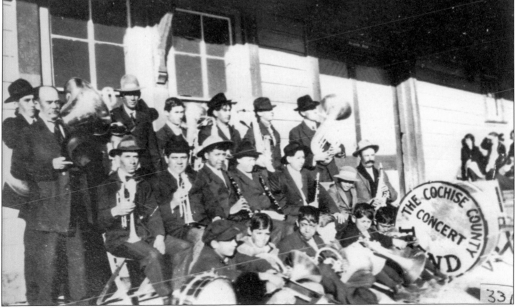

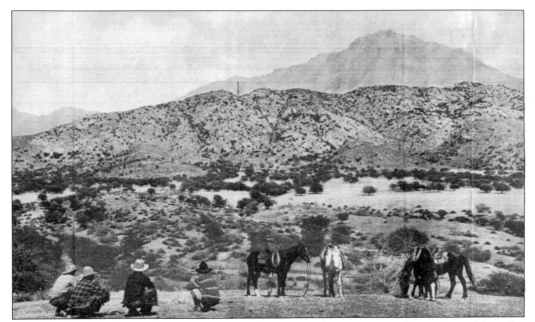

Dude ranches in southern Arizona thrived in the 1930s and 1940s, accessed by rail travel from the East. Some popular spots near Benson were the Bar-O-Ranch, Seven Dash Ranch, and Triangle T. Triangle T in the 1940s also served as an internment camp for Japanese dignitaries who had been surprised by the bombing of Pearl Harbor and were exchanged for American dignitaries similarly surprised in Japan. (Arizona Historical Foundation.)

This Civilian Conservation Corps includes Albert Comaduran of Benson, second from left. They traveled through the Southwest, building mountain trails and other improvements. (Comaduran collection.)

Parties, of course, always provide diversion, and mid-20th–century Benson residents loved them. Halloween parties, especially, enjoyed popularity, complete with homemade costumes. (Comaduran collection.)

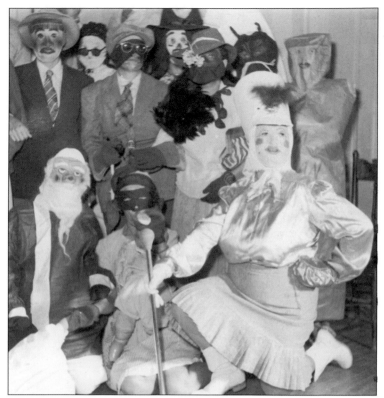

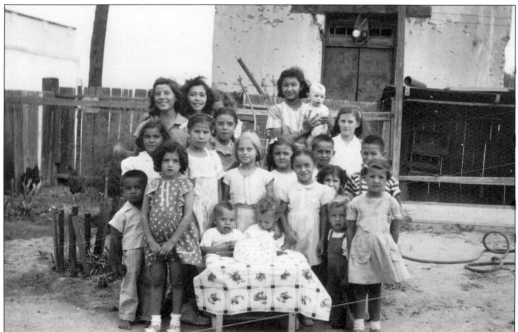

In the Catholic community, birthday parties celebrated everyone's birthday—a community birthday party! Children of all ages from the neighborhood attended, sharing the honor of the birthday cake. (Comaduran collection.)

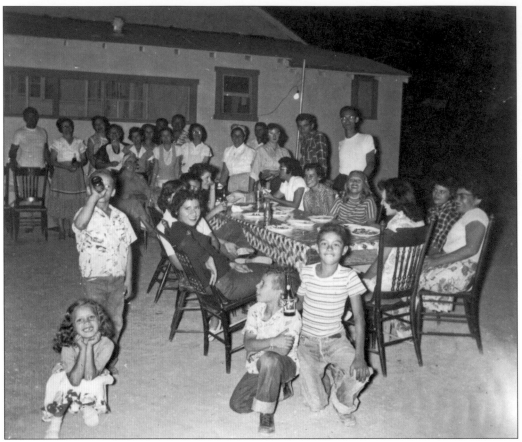

The Wo sisters took partying to a higher level with their ice cream parties, attended by guests of all ages. (Comaduran collection.)

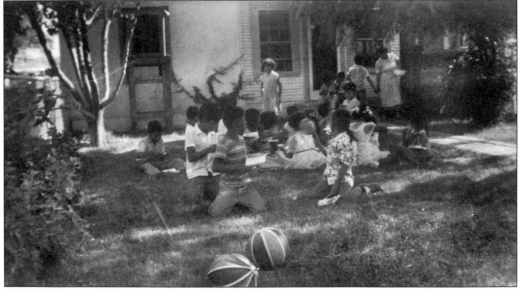

Birthday parties took on a more age-related look in the 1950s. (Comaduran collection.)

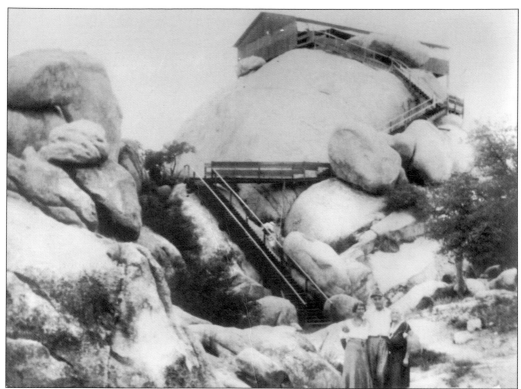

Purely adult entertainment occurred at the Skyline, a dance hall on the rocks in Texas Canyon. No alcohol was served, but people could go to their cars for a nip if they did not mind climbing the 150 steps to the dance hall. A shooting occurred here once, and a cowboy was injured, though with just a scratch. That incident, however, launched a serious romance between him and the daughter of William Shirley Fulton, founder of the Amerind Foundation not far away. Although her papa disapproved, Liz Fulton later married the cowboy, Kenny Gunner. The Amerind Foundation, founded in 1937, still provides a museum, art gallery, workshops, and an archaeological research library in Texas Canyon near Dragoon.

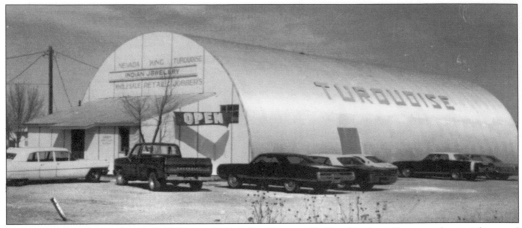

Recreation in the 1950s and 1960s included the Benson Roller Rink, a Quonset hut with wood floor, owned by Garnet Barker. By the 1960s, it was used as a turquoise sale room.

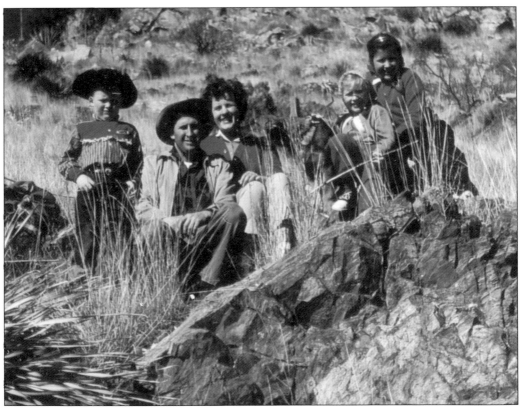

Winter recreation for these Midwesterners in the 1950s involved spending time in Arizona. Pictured on a hill in the Whetstone Mountains are the author, E. K. Suagee (second from right), with sister Cristy, brother Kim, and parents, Gale and Carolyn Criswell. In the 1980s, cavers discovered a major cavern under this hill, later named Kartchner Caverns.

Six

GROWING A TOWN

During the economic scare between 1907 and 1912, the railroads pulled out of Benson one by one and set up operations in Tucson. The Sonoran Line from Nogales was rerouted to Tucson instead. Apache Powder Company still required rail service, but service farther south was soon curtailed. Southern Pacific maintained a depot in Benson until the 1970s, then that, too, was abandoned.

Ranching and agriculture stepped in to save the day. With artesian water in plentiful supply, once a well was drilled in the right place, farmers no longer had to rely on river water and rainfall to irrigate. Green fields of alfalfa, oats, barley, corn, squash, and cotton sparkled in the sun. Benson took on the look of a modern Western town, with cowboys in abundance.

During World War I, the federal government took over operation of the nation's railroads, hampering growth of the industry, but since Benson had already suffered loss of its status as a railroad "hub," the town felt only a positive effect from the increase of railroad traffic.

Increased automobile traffic brought auto courts and restaurants to Benson. State Route 86 was graded, linking Benson directly to Lordsburg, New Mexico. Although only a dirt trail until 1941, SR 86 still reduced traveling time between east and west by over 60 miles over the established route, SR 80. Southern Arizona also began to entice tourists as dude ranches and rodeos proliferated.

At the end of the 1920s, Benson had a growth spurt, building new schools and a town hall. Another growth spurt happened after World War II, with new churches and another new school. But Benson is hard on buildings. The soil in this precipitous valley slips and slides, ruining some. In the 1970s, an arsonist targeted schools, the museum, and the movie theater. Rash decisions were made following some of these crises, and buildings were destroyed rather than repaired. Consequently, Benson lost much of its ambience.

Homes along Sixth Street on a snow day in the 1940s portray a modest life for most Benson residents.

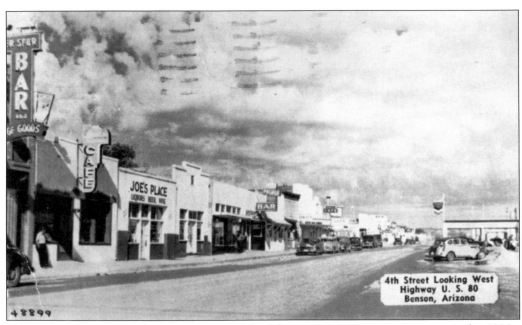

When the Sunset Trail (SR 86) connected Lordsburg, New Mexico, to Benson in the 1930s, automobiles no longer had to take a time-consuming loop through Douglas. Fourth Street illustrates the importance of automobiles to the commerce of town. Where once the rails of the Arizona and South Eastern Railroad lay, now gasoline filling stations adorned the street, while restaurants and bars still decked the other, offering travelers a variety of refreshment.

Dr. James Morrison and his wife, Petra, sit in rockers on their porch (right). They lived through the changes in Benson from railroad town to the modern era. He was also a lawyer and is known to have once represented lady outlaw Pearl Hart. In 1937, he stands before his office window (below) printed with his distinction from other doctors, "Desert Surgeon," a title he earned by reattaching the severed legs of a Mormon child who had been injured in a haying accident. Both legs recovered, and the child lived a normal and productive life. Dr. Morrison arrived in Benson in 1898 and died, quite poor, in 1941, with many people owing him money. His grave, unadorned for years, finally received a stone in 2007, thanks to the efforts of Louise Larson of Pomerene.

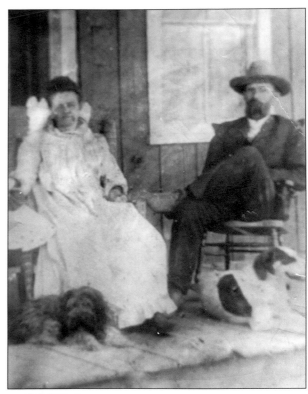

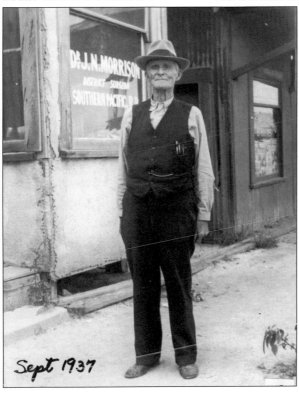

Sept 1937

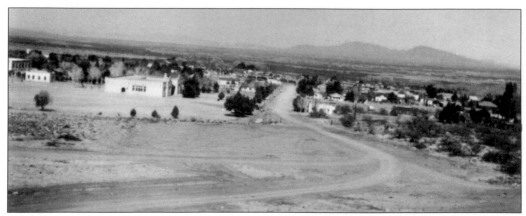

Looking north down Patagonia Street about 1940, Benson Grammar School and Benson High School occupy the large campus to the left. The town has grown south past Ninth Street. Patagonia Street is still dirt, and down the west side runs a drainage canal. In 1896, violent storms caused a flood that swept an early home down this street all the way to the San Pedro River, killing seven people.

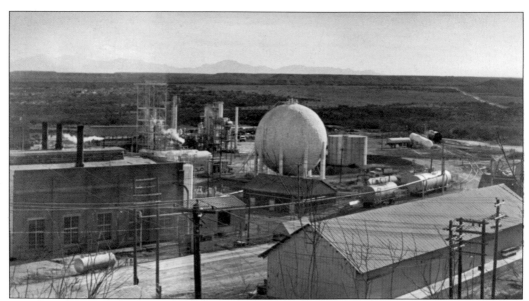

One of the reasons for Benson's growth was Apache Powder Company, a subsidiary of Phelps Dodge, which was built near St. David in 1920 to provide explosives for the mines. The plant's executives lived in homes built along Sixth Street west of Patagonia Street, and the plant employed around 200 people. It later changed production to ammonia nitrate, used in farming, and it still operates today.

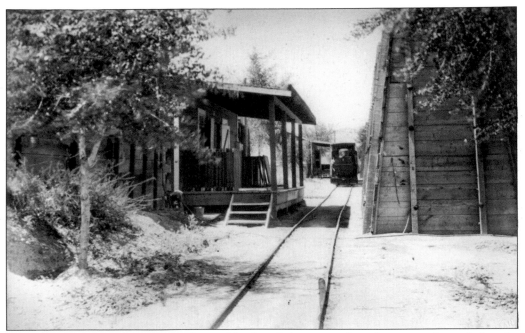

Inside Apache Powder Works, the front of the "smokeless engine" can be seen at the end of tracks laid to move materials around. "Smokeless" was necessary because Apache produced explosives. Inside the building, the engine ran on two-by-fours to prevent sparks. The shed to the right was reinforced to withstand explosions.

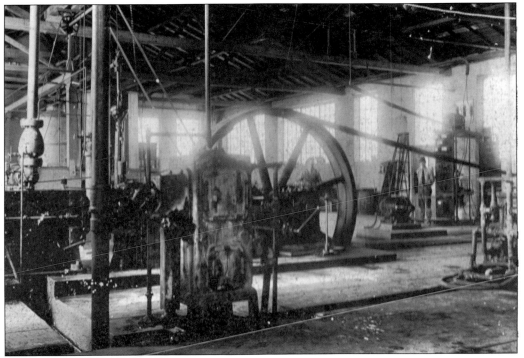

Inside the shop, machinery seems idle at this time. Apache Powder doubtless was built far from town in case of error that might cause an explosion. It has not been without errors.

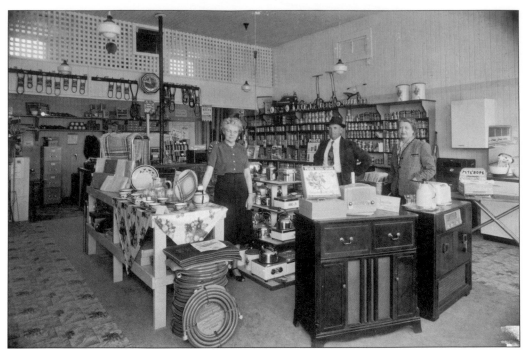

Back in town, commercial enterprises changed with the times. Benson Home Supply, at the southwest corner of Huachuca and Fourth Streets, seems ready for a variety of needs, from engine belts on the walls to furniture and dishes for the home, and groceries too, of course.

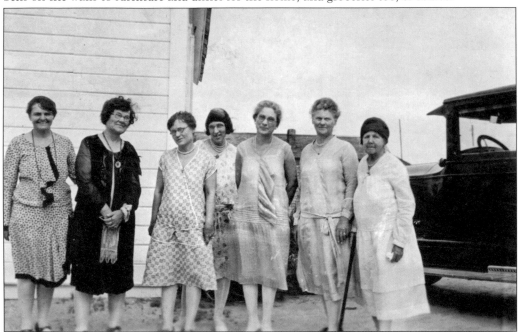

Social clubs filled a dual need: the need for ladies to get together and the need for projects to be done around town. In 1928, the Benson Women's Club joined the talents of, from left to right, Mrs. Jay Emmons, Mrs. J. H. (Josephine) Getzwiller, Mrs. Leon Moss, Mrs. M. H. Davis, Mrs. A. W. (Mary) Bard, Mrs. W. F. Jones, and Mrs. C. S. Powell.

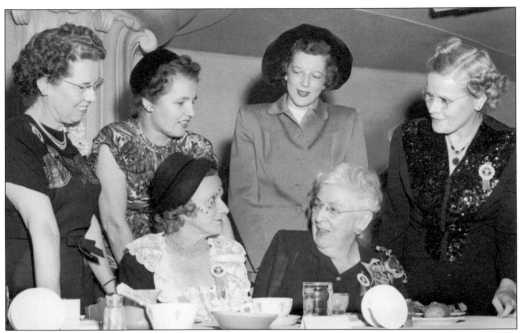

Another group of women meet in the 1940s to honor Mrs. A. W. (Mary) Smith as Arizona's first woman banker. Mary Smith (first row, right), a lawyer and a bank officer, shared her knowledge with a wide range of state colleagues.

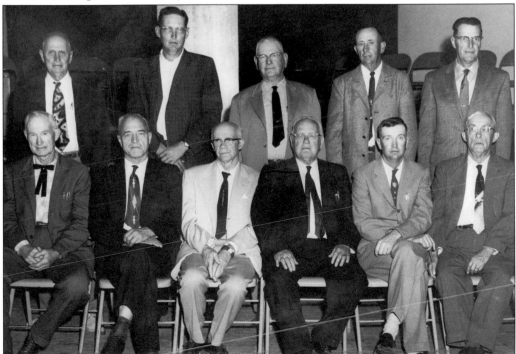

The Sulphur Springs Valley Electric Cooperative Board (shown around 1960) included three men from the San Pedro Valley. In the first row, from far left to right, they were Franklin East (Pomerene), James Kartchner (St. David), and Mervin Davis (Benson).

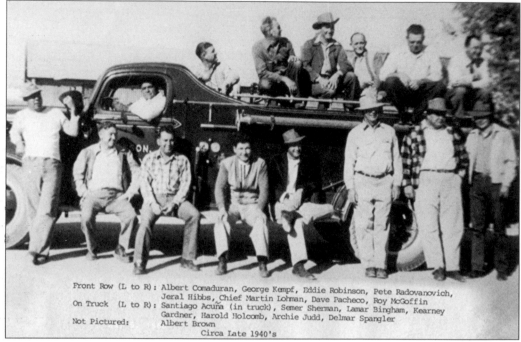

Front Row (L to R): Albert Comaduran, George Kempf, Eddie Robinson, Pete Radovanovich,
 Jeral Hibbs, Chief Martin Lohman, Dave Pacheco, Roy McGoffin
On Truck (L to R): Santiago Acuña (in truck), Semer Sherman, Lamar Bingham, Kearney
 Gardner, Harold Holcomb, Archie Judd, Delmar Spangler
Not Pictured: Albert Brown
 Circa Late 1940's

By the 1940s, Benson had a volunteer fire department with an enthusiastic crew of able-bodied men. Pictured from left to right are (first row) Albert Comaduran, George Kempf, Eddie Robinson, Pete Radovonovich, Jeral Hibbs, Chief Martin Lohman, Dave Pacheco, and Roy McGoffin; (in the truck) Santiago Acuna; (on the truck) Semer Sherman, Lamar Bingham, Kearney Gardner, Harold Holcomb, Archie Judd, and Delmar Spangler. Albert Brown is not pictured.

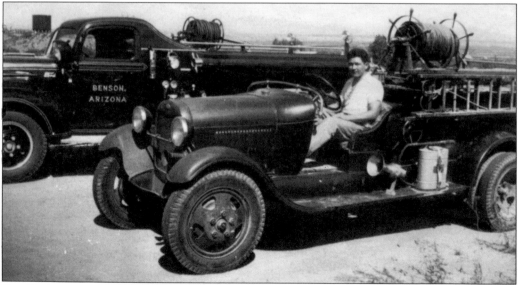

Pete Radovonovich drives the older hose-and-ladder truck. No doubt the truck behind him was new at this time. The water tower in the background places this location close to Gila Street. Coincidentally, Benson's Fire Station is currently (in 2008) at Gila and Seventh Streets.

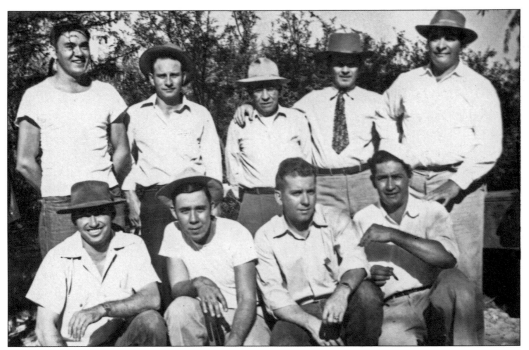

These firefighters vary in age and experience, but the one at lower right appears to have just left the navy around 1940. Albert Comaduran is second from left in the first row, with Eddie Robinson next to him, third from the left. Eddie was later a chief.

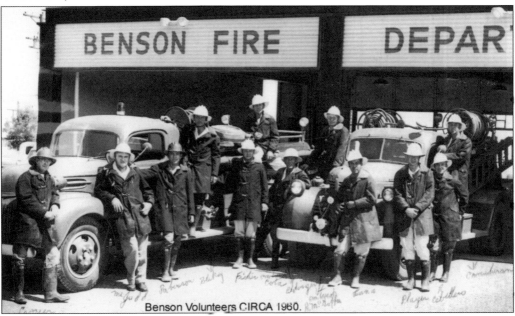

Benson Volunteers CIRCA 1960.

Benson Volunteer Fire Department around 1960 still used the 1940s equipment: at left, a 1946 Ford Howe Pumper and, right, the Dodge war surplus pumper. Some of the firemen are the same as well: (from left to right) Johnny Crozier, Archie Judd, Chief Eddie Robinson, Bill Blakey (on the truck), Ken Fischer, Joe Cota (on the truck), Rudy Aldinger, Roy McGoffin (on the truck), Joe Luna, Sam Player, Rudy Caballero, and Albert Comaduran (on the truck).

Young James M. Hesser came to Benson in 1945 after military service at Davis Monthan Air Force Base in Tucson and bought the practice of Dr. Alexander N. Shoun. A strapping lad, James had wrestled in high school and college in Oklahoma, and he had taught wrestling as well. In 1946, James ("Doc") commissioned work on a hospital at the corner of Sixth and Huachuca Streets. Built of adobe blocks and completed in 1948, the Benson Hospital answered the needs of a growing community for advanced health care, growing to a capacity of 20 beds.

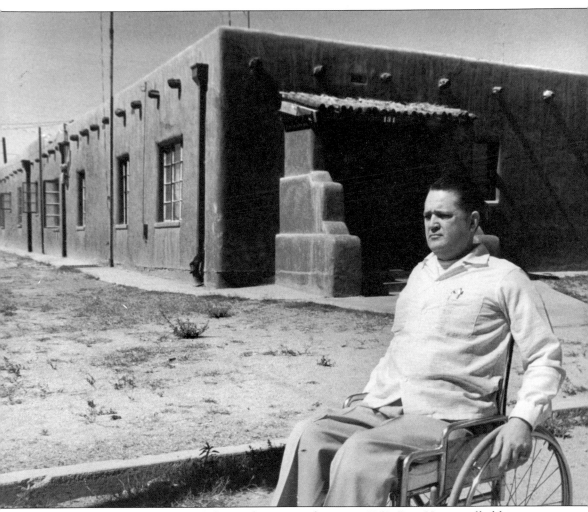

In his haste to get to an automobile accident west of town in 1950, Doc Hesser rolled his car, severing his spine. Despite being confined to a wheelchair for the rest of his life, he continued working in medicine, building a practice and improving his hospital. In 1960, he retired and moved to his farm in St. David, selling the practice to doctors Max and Dean Kartchner. The hospital remained in operation until a new hospital was built in the 1970s. Then this building became a city property, housing the library and police department, until it was torn down in 1988 to make way for a new library.

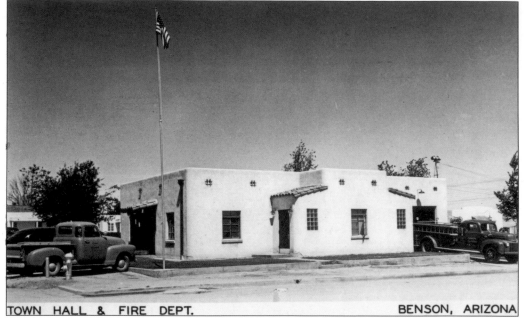

TOWN HALL & FIRE DEPT. BENSON, ARIZONA

The first Benson Town Hall and Fire Department, built around 1936, continued a mission style
of architecture perhaps inspired by the previous construction of Benson Grammar School by
Josiah Joesler and echoed by the new Benson Hospital, down the street, in 1946. Prior to this,
the town council met at the Women's Club.

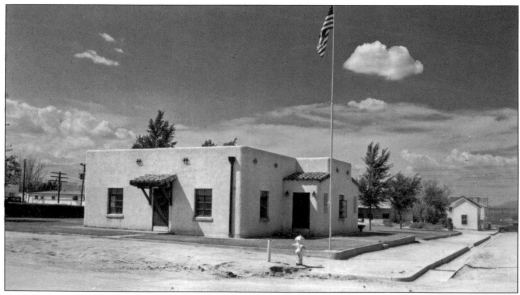

Another shot of Benson Town Hall shows the corner and fire hydrant at Huachuca and Fifth
Streets. The residential streets remained unpaved until 1966.

A new town hall was erected on the same site in the 1957, probably because more office space was needed. The much less attractive modular-type building was built on pylons for easy adjustment when soils slipped. Benson's status was changed to the City of Benson in 1985.

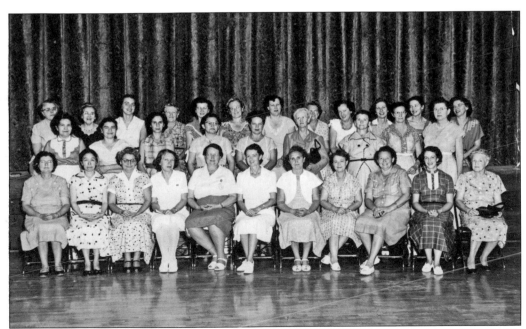

This group of ladies, dubbed "Mothers of the Band," raised money for new band uniforms badly needed in the early 1960s. Benson bands excelled at state competitions under the directorships of Howard Teague and Bill Morris.

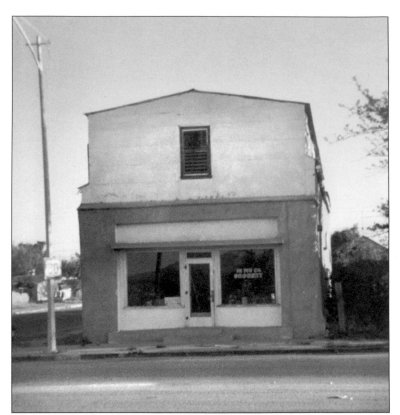

The Hi Wo Grocery sold dry goods and groceries until the 1980s. The last surviving Wo sister, Soledad, died in 1991.

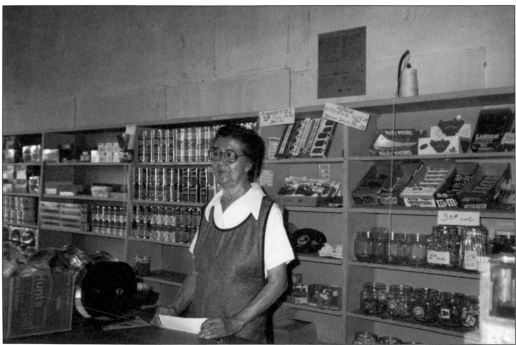

Soledad kept her goods in order. Judging by the price of the candy bars, this appears to be toward the end of her life as shopkeeper. (Comaduran collection.)

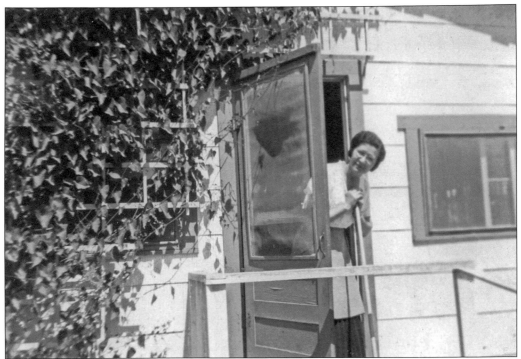

A younger Soledad Wo greets the photographer outside her back door. (Comaduran collection.)

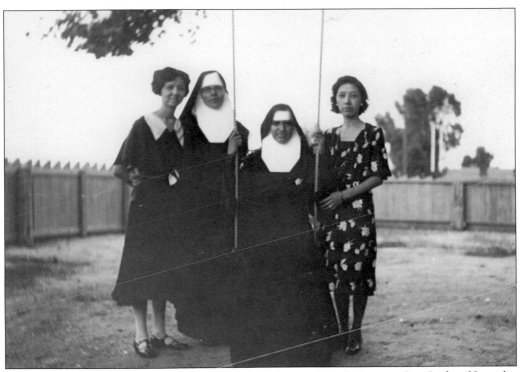

The Wo sisters welcomed nuns into their home for an annual event at Our Lady of Lourdes Catholic Church. (Comaduran collection.)

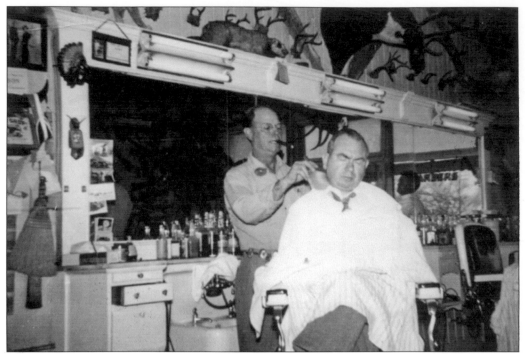

Val Kimbrough was a colorful character who owned a barbershop in the 1950s and was a one-time town mayor. The barbershop resembled a taxidermist's lair. Here he gives pharmacist Dick Hamilton a trim. Kimbrough told customers his building once housed the Wild Cat Bar, where a shoot-out on Thanksgiving Day 1906 between the owner, Harry Fisher, and his bartender, "Jack the Ripper," resulted in Jack's death.

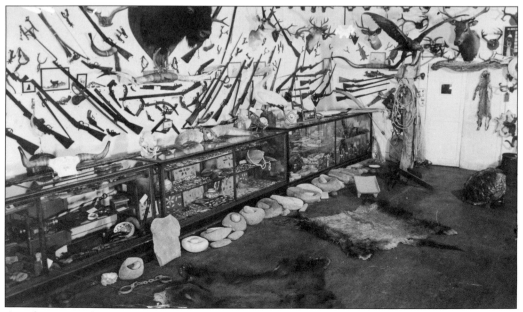

Another view of Val Kimbrough's barbershop reveals everything from *matates* (Native American grinding stones) to an antique gun collection.

Seven

NEW TRAILS TO BENSON

As the century moved forward, Benson relied on automobile traffic to supplement needs of local residents for goods and services. Tourism became very important to the economy. Ranchers and farmers still operated outside town, Apache Powder Company still made ammonia nitrate nine miles south, and many residents still did much of their shopping in Benson, but change was coming. The automobile was both a blessing and a curse.

When Interstate 10 circumvented Benson, the town was transformed. The *Arizona Republic* insert dated July 14, 1974, foretells the effects of the bypass. In a picture of Fourth Street on June 5, 1974, traffic was thick; the next day, when the freeway opened, motorized traffic was reduced by about three-quarters. Tourism had supported much of the business in Benson, and now those tourists were whizzing on to Tucson or points east. What's worse, Benson residents were taking the freeway to Tucson for greater variety in shops as well.

In 1980, its centennial year, Benson's population had reached about 3,000. Arizona Electric Power Cooperative had established its main office in Benson in the 1960s, but the railroad no longer maintained its presence. In fact, the arts and historical society had possession of the depot building, and it had been moved to the park, where it was used as a museum until it was destroyed by fire. The movie theater had been destroyed by arson, and many other public buildings had been damaged, including the high school built in 1929. The grammar school (middle school) had been demolished simply because of a roof leak. Many of the shops downtown had closed.

As in past times of economic hardship, few Benson families considered leaving. Pioneer families, indeed, continue to keep Benson alive. So does tourism. Winter visitors, "snowbirds," began swarming to Benson in the 1980s. Many elected to stay, built homes, started businesses, and inspired a new wave of development based on the most basic resources of all: land and water. Benson's small-town attitude tempted others as well—the fortune seekers of the new century.

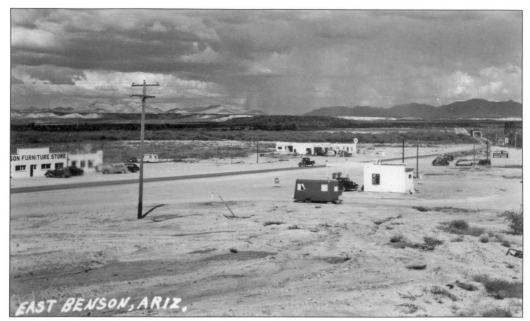

An obvious but neglected trail east, the road that became State Route 86, the "Sunset Trail," followed closely the Southern Pacific Railroad's route to New Mexico. Traffic had been routed by U.S. 80 (the Broadway of America) to Douglas because Phelps Dodge had its offices there and at Bisbee, but that route added over 60 miles to an east-west trip. Travelers were grateful for this shortcut. (Bob Nilson.)

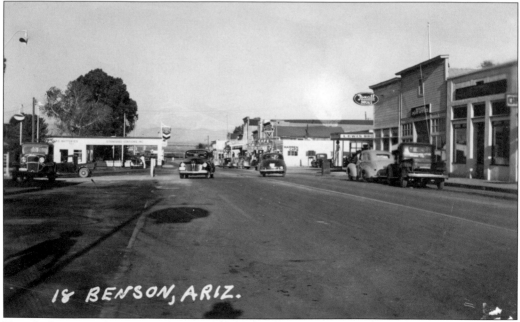

Fourth Street in the 1930s provided all the traveler or local patron might need. The Rexall drugstore and Lewis Brothers Garage flank Huachuca Street. Filling stations line the north side of Fourth Street where Arizona and Southeastern tracks once were. (Bob Nilson.)

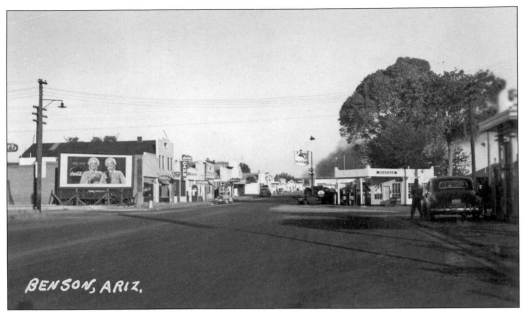

From the east end of Fourth Street around 1940, a billboard advertising Coca-Cola replaced the Maiers Brothers building. The pool hall, café, and restaurants are joined by a movie theater about mid-block. (Bob Nilson.)

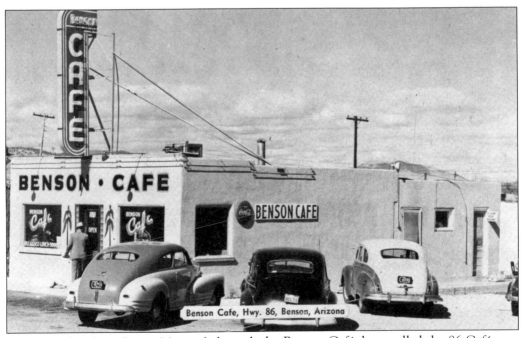

Not long after State Route 86 was dedicated, the Benson Café, later called the 86 Café, was doing good business in east Benson. Built of railroad ties, this building burned down in the late 1980s. (Bob Nilson.)

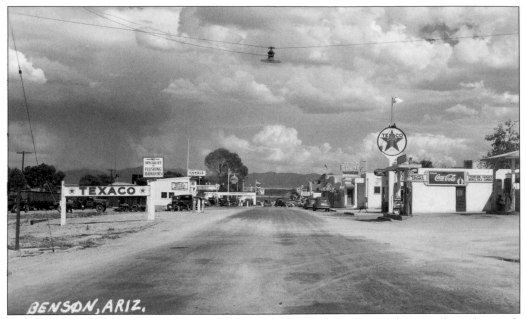

Fourth Street, looking east, shows the Horseshoe Café and the San Pedro Motel on the south side of the street and numerous garages and filling stations on the north side. The railroad depot can be seen through the Texaco sign on the left. The Horseshoe Café opened the 1930s and operated until 2008. (Bob Nilson.)

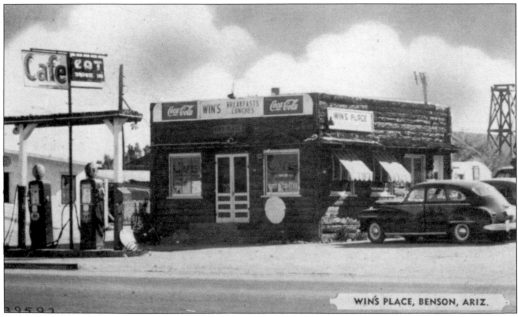

Win's Place, farther west on Fourth Street at Land Avenue, sported a different look—log cabin style. (Bob Nilson.)

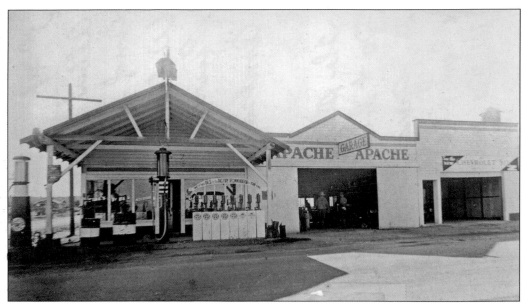

Apache Garage leased land from the railroad on the north side of Fourth Street.

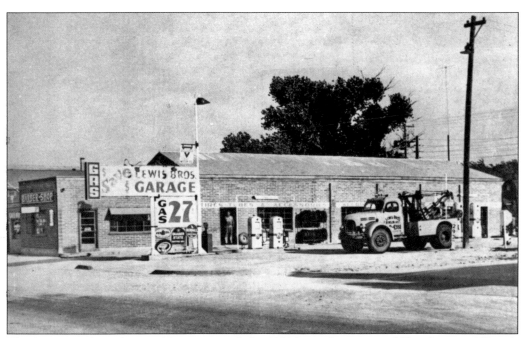

The Lewis Brothers Garage (shown around the 1950s), on the corner of Huachuca and Fourth Streets, offered a neat arrangement for those wishing to receive a haircut from Roland Mayberry while they waited for vehicles to be serviced.

One of the first auto courts and arguably the biggest was Camp Benson, later named the Benson Motel. Besides individual units with carports, this uptown establishment offered a swimming pool to weary travelers. (Bob Nilson.)

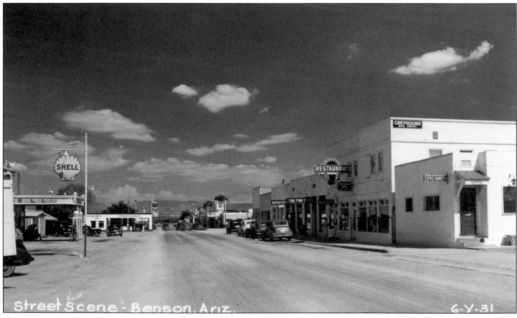

A street scene in 1940s Benson reveals that the Horseshoe Café has added a floor. The owners also commissioned Vern Parker to paint murals on the walls. Abe Samuels owned the Fair Store, later buying the grocery next door to make the Variety Store. The post office and Citizens Bank are next, with the drugstore at the corner. The post office moved in the 1950s, and the bank took over that space, too. (Bob Nilson.)

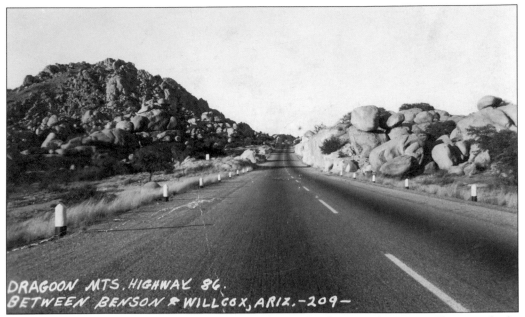

State Route 86 passed through Texas Canyon about 15 miles east of Benson. This view looks east. The road behind the cameraman was called the 15-mile hill, describing the length of a precipitous climb of over 1,000 feet out of the San Pedro Valley to the pass. Texas Canyon marks the northern edge of the Dragoon Mountains. (Bob Nilson.)

A marker at the Catarina and Fourth Streets intersection points travelers to the Sunset Route (Highway 86) before the route was paved or the Benson Underpass was constructed. The other arrow marks the way to Bisbee and Douglas via Route 80. When the underpass was constructed in 1941, all the buildings seen here were obliterated. (Arizona State Library, History and Archives Division, Phoenix, No. 02-1512.)

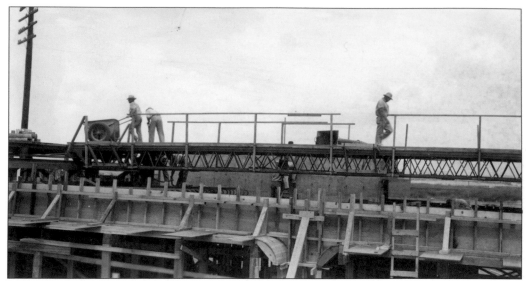

Considered a masterful solution to the problem of railroads being in the way of automobiles, the Benson Underpass, constructed in 1941, eliminated a possible collision of these two major forms of transportation at the railroad's curve into Benson. (State Library, History and Archive Division, Phoenix, 93-0952.)

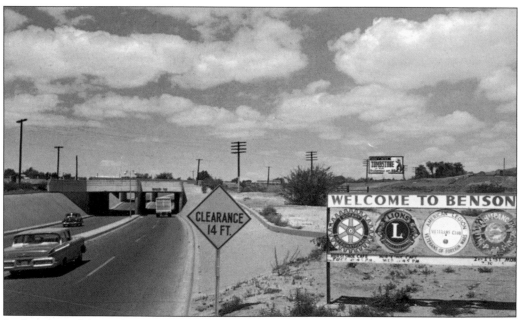

In this view of the underpass from the east, one sees the double overpass construction. The first bridge over the road supports the railroad tracks, the second, the supports of which can be seen, carries traffic from the south, Route 80, over the roadway for Route 86. They merge going west on the other side.

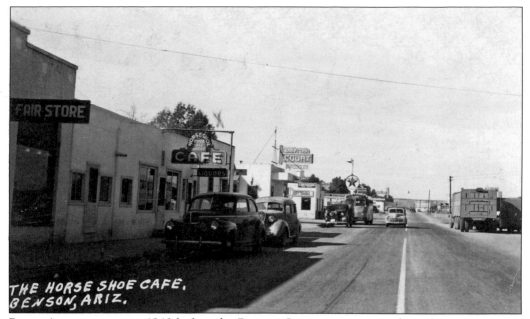

Benson's main street in 1940 before the Benson Overpass maintained a sedate appearance. Although that route had been used for automobile traffic since 1913, it was not accepted into the state's road system until 1936, and it was not paved until 1941. The natural shortcut was resisted by Douglas and Bisbee, stronger politically than Benson.

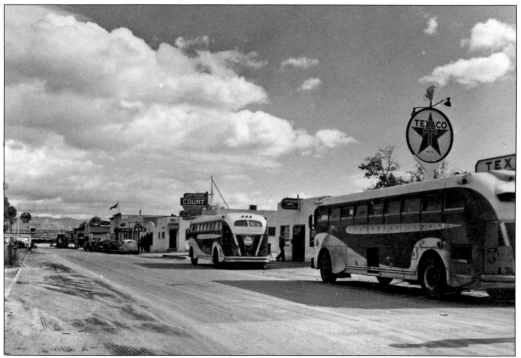

Bus travel proliferated from the 1940s through the 1980s. In the early 1940s, these Greyhound busses stopped at the terminal on Fourth Street. Down the block, a flag waves over where the post office still does business. (Bob Nilson.)

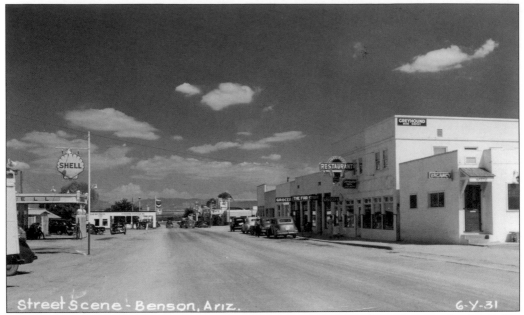

By the late 1940s, the Horseshoe Café doubled as the Greyhound Bus Station. In the 1960s, busses found the alley behind the Horseshoe Café more convenient. Restaurant patrons often made their way around someone's luggage to get to their tables. (Bob Nilson.)

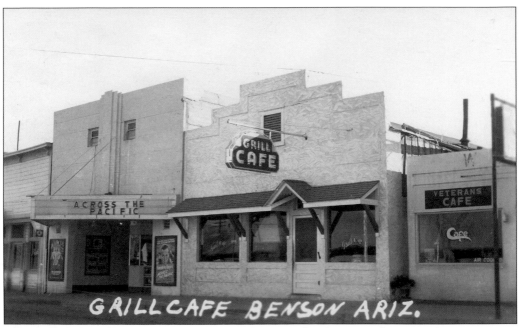

The Grill Café and Veterans Café, positioned next to the theater, indicate ample patronage to support restaurants side by side. Both the Veterans Café and the movie title suggest this picture was taken near the time of the Second World War.

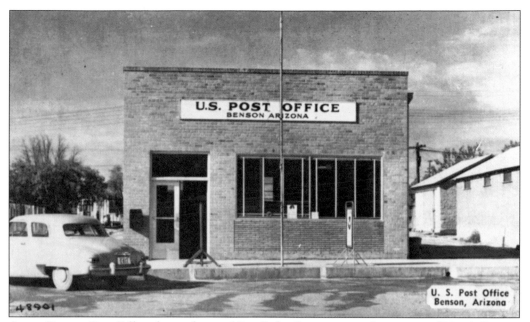

A new Benson Post Office, located east of San Pedro Street next to former site of Moss's Service Station, went into service in 1947.

The post office was moved again in the early 1960s, this time to the corner of Huachuca and Fifth Streets, across from town hall. This was pre-1966 because the roads are still dirt.

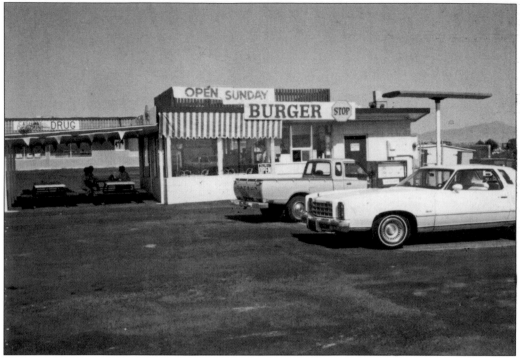

In the 1970s, a new shopping strip on Ocotillo Road in west Benson harbored the Burger Stop, a new level of Benson dining. (Bob Nilson.)

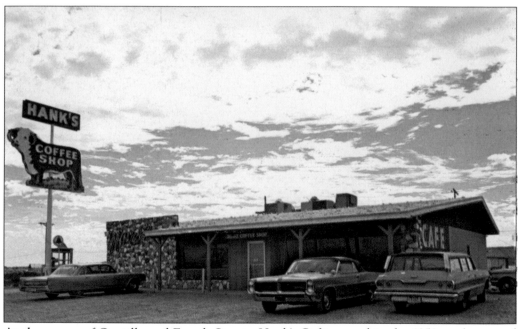

At the corner of Ocotillo and Fourth Streets, Hank's Café opened in the 1950s and operated until 2000. It once sported a plastic cow on its roof. The Randy Galleano family now operates a thriving business, serving American and Italian food. (Bob Nilson.)

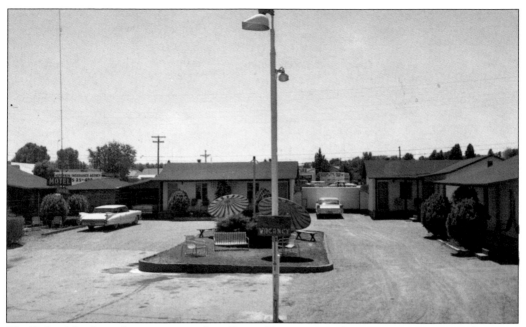

The Delux Motel, another auto court along Route 80, invites travelers to enjoy some sun in the grassy median area. Part of this auto court still exists behind Scott's Service Station. (Bob Nilson.)

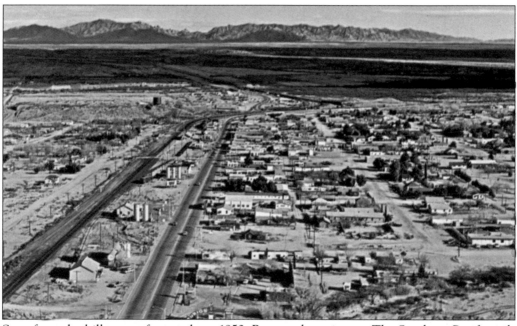

Seen from the hills west of town about 1950, Benson shows its age. The Southern Pacific rails continue through town, connecting with Arizona and Southwestern (formerly New Mexico and Arizona) tracks that go south to Apache Nitrogen (Powder) Plant. State Route 86 merges at the underpass with SR 80, which curves from the south. The streets are wide and clean. Benson rests before its final challenge—the interstate highway system.

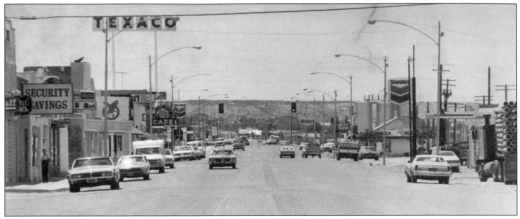

A busy town of 3,000 in 1974, Benson and its Fourth Street before the bypass evoke the opinion of early travelers that Benson bustles with activity. Traffic was so thick in 1968 that a stoplight was added to the Patagonia Street intersection. Notice the Rexall Drugs sign, the bank, the bar, the Horseshoe Café—these storefronts have not changed. Yet opening the interstate would change many things, beginning with traffic.

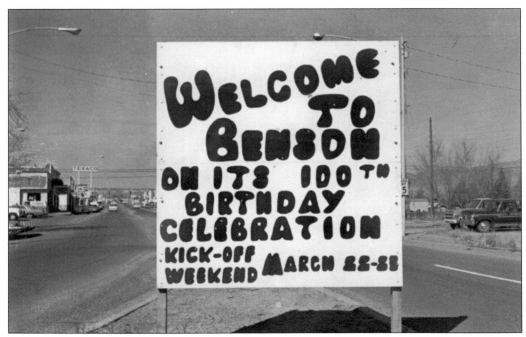

Where the Broadway of America meets the Sunset Trail in 1980, a homemade sign announces Benson's 100th birthday celebration. On the street behind this sign, very little traffic is evident—certainly not the constant streams of automobiles that warranted the town's first stoplight. Today citizens resist attempts by the state to tear down the underpass and build a different intersection because the structure is part of our story.

126

SELECTED BIBLIOGRAPHY

Benjamin, Stan. *Benson, Arizona: One Hundred Years of Law Enforcement.* Tucson, AZ: Self-published, 2002.

The Cochise County Historical Journal 30, no. 1 (spring–summer 2000).

DuBois, Susan M., and Ann W. Smith. *The 1887 Earthquake in San Bernardino Valley, Sonora: Historic Accounts and Intensity Patterns in Arizona.* Special Paper No. 3, State of Arizona Bureau of Geology and Mineral Technology. Tucson, AZ: University of Arizona, 1980.

Franke, Paul. *They Plowed Up Hell in Old Cochise!* Douglas, AZ: Douglas Climate Club, 1950 and 1961.

Myrick, David F. *Railroads of Arizona, Vol. I: The Southern Roads.* San Diego, CA: Howell-North Books, 1975 and 1981.

Sonnichsen, C. L. *The Ambidextrous Historian: Historical Writers and Writing in the American West.* Norman, OK: University of Oklahoma Press, 1981.

Wilharm, Peter B. "Research from ADOT Library." 1970.

ACROSS AMERICA, PEOPLE ARE DISCOVERING SOMETHING WONDERFUL. *THEIR HERITAGE.*

Arcadia Publishing is the leading local history publisher in the United States. With more than 4,000 titles in print and hundreds of new titles released every year, Arcadia has extensive specialized experience chronicling the history of communities and celebrating America's hidden stories, bringing to life the people, places, and events from the past. To discover the history of other communities across the nation, please visit:

www.arcadiapublishing.com

Customized search tools allow you to find regional history books about the town where you grew up, the cities where your friends and family live, the town where your parents met, or even that retirement spot you've been dreaming about.